west marin review

2 0 1 2

04

A Publishing Collaboration

POINT REYES BOOKS

NEIGHBORS & FRIENDS

PROSE

POETRY

ABOVE Carolyn Means, *Red Glow: Wood-Fired Tea Bowl,*
2010, stoneware clay, 3½ × 4 × 3½ inches

ART + ARTIFACT

MUSIC

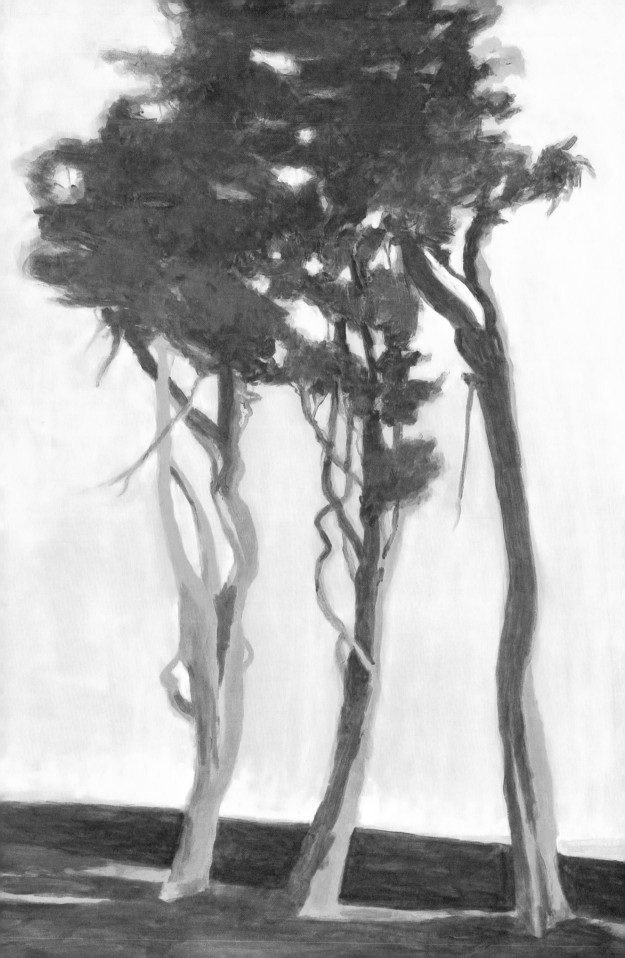

Dear Reader

WELCOME TO Volume 4 of the *West Marin Review,* an award-winning literary and art journal published by Point Reyes Books and an all-volunteer group of friends and neighbors.

People ask, Is the book *about* West Marin? Are contributors *from* West Marin?

The *Review*'s focus is not limited to our corner of rural northern California, and its contributors are not necessarily West Marin residents, but this place of great natural beauty, open spaces, and public lands does seem a magnet for creative people. In the abbreviated biographies in the back pages, you'll find that many of the talented writers and artists contributing to this volume do live here. Others are from urban and rural places near and far—the Bay Area, across the country, and sometimes across the seas. We are proud to include well-known authors and artists in these pages side by side with the art and poetry of local schoolchildren and other emerging talent published here for the first time.

West Marin inherits Native American and immigrant cultures along with a history of agriculture and ranching, and these influences all reach into this journal. But perhaps most influential to the identity of this place is the presence and protection afforded by its public lands: in particular, the Point Reyes National Seashore, occupying lands and seashore west of Highway One, and the Golden Gate National Recreation Area (GGNRA), occupying lands east of the highway.

This volume's featured history takes us back to the mid-1970s, when the GGNRA's boundaries were being drawn. In "How Rep. Phillip Burton and a Magic Marker Hijacked Tomales Bay into the Golden Gate National Recreation Area," George Clyde conducts a

Susan Hall, *Old Cypress,* 2011,
oil on linen, 18 × 24 inches

dramatic investigation, makes an extraordinary discovery, and finds the solution to a thirty-five-year-old mystery.

Clyde's essay is a colorful story in a book full of colorful writing (Alvin Duskin's "Uncle Dave"), art (Kaya Gately's "Hummingbird," Kathleen Rose Smith's "Sun Woman Triptych," and Thomas Joseph's "Bodega Bay" are only a few examples), and music (Bart Hopkin's bright adaptation of a Jamaican folk song for guitar and voice or other instrument).

There are pieces to make you smile: Joan Thornton's revisioning of a classic tale in "Gretel," the story "Etiquette" by William Masters, the poem "covenant" by Gina Cloud. And there are fascinatingly informative essays, as in F. J. Seidner's erudite "Collecting," alongside which Carola DeRooy's abstract on a Coast Miwok basket, "The Language of Baskets," gains in dimension. There are also ghosts fluttering across the pages. Chekhov haunts Susan Trott's short story, "About Bunin," much as Jake Velloza haunts Michael Parmeley's remembering, "Jake's Memorial." "Nouns" are the elusive ghosts in Helen Wickes's poem.

You'll find other gifts and happy surprises here. The *Review* is a book whose pages open not only to the natural world, but to the world where love and loss exist, where politics has its effect, where people get stuck in elevators and boys receive haircuts, whether they want to or not.

We hope you'll enjoy this year's *Review* in all its diversity, and that if you're inspired to, you'll send us your own work for our next volume. Look for submission guidelines at westmarinreview.org.

POEM Jane Hirshfield, "Many-Roofed Building in Moonlight" (excerpt from poem on page 110)
ART Kaya Gately, Grade 7, *Hummingbird,* 2011, gouache, 7 × 5½ inches

I found myself
suddenly voluminous,
three-dimensioned,
a many-roofed building in moonlight.

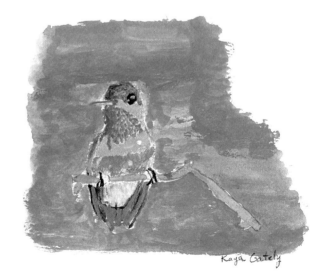

Planh or Dirge for Those Who Die in Their Thirties

Robert Hass

If life is a day, then thirty-three—
There's a green wind on the pond,
It's summer on the pond—

Is near to an unshadowed noon.
There's a green wind on the pond,
It's summer on the pond.

Frank O'Hara, Lester Young.
It's summer on the pond.
There's a green wind on the pond.

Sylvia Plath, Arthur Rimbaud.
There's a green wind on the pond.
It's summer on the pond.

Our Peter at thirty-six.
It's summer on the pond.
There's a green wind on the pond.

And Eden pregnant seven months.
It's summer on the pond.
There's a green wind on the pond.

He was running a 'half-marathon.'
There's a green wind on the pond.
It's summer on the pond.

We threw white roses in the grave.
There's a green wind on the pond.
It's summer on the pond.
It's summer on the pond.

Cynthia Pantoja, Grade 12, *Serenity*, 2012, pen on paper, 12 × 5½ inches

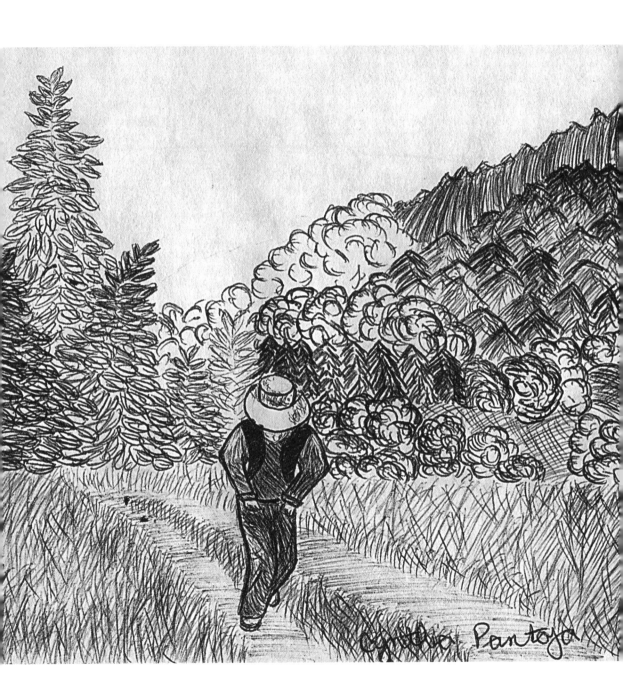

A Taste for Action

Joan Thornton

She says she likes poems with people in them,
she likes a poem to be an egg with a window
that she can look into and see people doing
things she understands, doing something she
might do, or at least contemplate. She says,

"It's the fact that they move that moves me.
For instance, a poem describes two sisters
on the outs, and that could be the end,
a still life, but I won't like it until they
do something, one steals a secret,
the other blows up the mall."

"That's a short story," I say, and she says,
"It's the movement I like, but it's the egg
with the window that makes it a poem."

Uncle Dave

Alvin Duskin

MY MOTHER worked at Snyder Brothers Knitting Mills as a sewing machine operator. The shipping department was on the floor below, and the sewing machine operators walked up the stairs past it on their way to the sewing floor. She always said "Good morning" to the shipping clerks. My father was one of them, the slim, good-looking one. One day my father stopped my mother on the stairs and whispered that someday he would have a factory like the Snyders. She whispered back that she would help him.

Betty Leibowitz and Max Duskin married in 1921, and my father continued to work at Snyder Brothers until 1936, when the company, like many others, went broke. My father didn't get another steady job for six years. The family bounced back and forth between San Francisco and Los Angeles as my father tried to get small contract shops going. In 1942 he got his first steady job in South San Francisco as a fire-watch at Western Pipe and Steel. My mother cried when he brought home his first paycheck along with a quart of ice cream. I was eleven and my sister was thirteen. My father had never before brought home a quart of ice cream. He would get a check for $44.44 every week!

"This is nothing," he said. "We're going to save some money, and when the war is over we're going to have a big factory and make sweaters. Outside the factory there's going to be a big sign that will say "BAMS KNITS" [B for my mother, Betty; A for me, Alvin; M for my father, Max; S for my sister, Sylvia] and we'll have everything we want." And that's what did happen. We didn't have everything we wanted, but

there was a big factory by 1958 and there was a sign that said "BAMS KNITS." For me, the best thing was now that my father had a job, we stayed in one place. After having gone to thirteen grammar schools in six years, I went to one junior high school, Portola Junior High.

During the war years when I was at Portola, my father's brother David worked on the docks in San Francisco, loading munitions on cargo ships. After the war he left San Francisco and went to New York, where he worked as a baggage handler on the docks and made extra money stealing suitcases. He would steal only the highest-quality suitcases, keeping any money and jewelry, giving monogrammed shirts and pretty dresses to his neighbors in Queens, and selling the suitcases to a shopkeeper whose store was nearby.

David's early life had been adventurous. The oldest of seven children, he had left home in 1910 at the age of seventeen and shipped out to China. He told me that he jumped ship in China and formed a detective agency in Shanghai with a partner named Little Joe Davis. Big Dave was five-foot-six and weighed about 240 pounds. Little Joe was three inches shorter and maybe 60 pounds lighter. When I was twelve Uncle David told me a story about an older woman in Shanghai who owned a house of prostitution. She would let him come to the house and have free access to all the girls as long as he ended up in her bed. I remember thinking, *Wow! In five years I'll be seventeen!*

Uncle Dave's business was nominally a detective agency, but he was selling opium and making a lot of money fast by importing women from Scandinavia to Shanghai, where blonde women were prized. Ultimately, he and Little Joe were run out of Shanghai, so they went north and teamed up with a warlord who was scheming to take over a northern territory. They rode around on horses brandishing swords and cut off people's heads and roasted chunks of dead horses and slept in huts. Then they were run out of China and went to Alaska looking for gold.

"When you grow up," my uncle told me when I was twelve, "we'll be a team! Dave Duskin and Nephew! But there may be times when we'll need to communicate secretly. So we must develop a code."

He stopped for a minute and took a pen out of his pocket. He found some paper and wrote on it. "Your code name will be 'Nivla Niksud.'" His code name was going to be Evad Niksud. Even at the age of twelve, I thought, *This is dumber than Little Orphan Annie's or Jack Armstrong's secret codes. Our enemies are going to look at 'Nivla' and not think that maybe this message is for Alvin?* But he insisted that we had to have a code. Okay. He was my hero, and except for the code, I knew he was smart and perceptive.

My mother's nephews, my Leibowitz cousins, were All-City athletes, and Uncle Dave knew that I envied them and felt that I had failed because I couldn't keep up with them.

"Alvin," my uncle said, "forget about those guys. Here's what we're going do. When you get a little bit older, in another five or six years, we're going to buy you a $200 suit." I thought, *"A $200 suit!"* (This was 1944, a candy bar was five cents, ice cream was ten cents, and a $200 suit was like saying to a kid today, "I'm going to buy you a $5,000 suit.")

"Then we're going to go to the Mark—the Mark Hopkins Hotel." This was the class thing in San Francisco, the top of the Mark!

"You'll sit at the bar and I'll sit way over in the corner and you just order a drink and you wait.

"After a while, a woman will come in, she'll sit down at the bar and you'll engage her in polite conversation. Then you'll look over at me and I'll shake my head 'no,' and so you'll politely get rid of her. But after a while a woman will come and I'll nod 'yes,' and then here's what you do.

"You walk over to her and say, 'Please tell me who you are.' She tells you her name. You repeat it. Slowly, looking into her eyes

as you say her name. You sit down next to her and you say, 'Tell me where you grew up.' And then you say, 'Tell me about your family,' and 'What do you want to do with your life?' I'll tell you other things to say, and you'll end up going home with her and she'll take care of you. I'll tell you what to do when you're alone with her to make her happy. You'll be built up a little by then. You'll be taller and have some muscles so she'll love you and she'll support you.

"Then you'll tell her that you really have to get on with your education. You have to go to New York to yeshiva to study to be a rabbi! She will understand. Tearfully, she'll give you a long kiss and send you off with your new car and your suits and ties and you'll go to yeshiva and you'll write long letters to her. I'll tell you what to write.

"I'll get a job in New York, and after you graduate and become kind of a junior rabbi we'll get you a job in Teaneck, New Jersey. You'll be the young rabbi!

"People will say to you, 'Do you have any family?' You'll say, 'No, I only have my uncle. My beloved Uncle Dave.' And these rich families who invited you in for dinner and stuff will ask, 'Well, what does your Uncle Dave do?' You'll answer, 'I don't really know. Uncle Dave seems to advise people about financial matters. But I really don't know.'

"'But why don't you bring him here to shul?' they'll say. And you'll say, 'Well, my uncle doesn't like to come here. He says that if I take care of everyone in this shul, God will take care of me. And the way God takes care of me is He gave me my Uncle Dave. But my uncle doesn't like to talk to me about Torah. He doesn't like to—you know.'

"This goes on for months. They keep saying, 'We'd like to know your family,' and so, eventually you bring me to shul. I'm polite, but I'm quiet and stay in the background. I socialize very little. Finally,

they convince you that you should invite Uncle Dave for a little financial consultation meeting. They get together and have a casual meeting and I concede, 'I'll advise you on a few things. But, you know, you can't make a lot of money with me. I'm very conservative. A little sweet cake with the bread, maybe, but only a little cake.' They get more and more confident about your Uncle Dave and you take some of the girls out for walks after family lunches and kiss them, but that's it, and everybody's competing to get you to marry their daughter and to get my advice.

"Finally, I agree to invest some money for these wealthy families in Teaneck, and they give me all their money, and then we go to Newark and we buy a boat and we sail off and we never go back! We sail around the Mediterranean and we have a terrific time. We go to this one port and all these beautiful girls are waiting for us, and then we go to the next port where more beautiful girls are waiting for us. We spend our whole lives sailing around and we never go back!"

Uncle Dave told me these stories in the kitchen of the railroad flat on Capp Street that he shared with his wife, my Aunt Sophie, and her sister, Vicki. Nobody in the family paid much attention to me and my uncle except, sometimes, my mother. One day Dave and I were sitting in the kitchen; he was drinking beer and telling me about his old times in Alaska beating up anti-Semites in bars, traveling in a dog sled and living in an igloo. I heard my mother coming down the hallway. As she got to the door and came into the room, Uncle Dave said to me, "Alvin, my boy, I've had man, woman, and beast, and I still haven't made up my mind."

My mother looked at him and said, "Oh, Dave, what are you saying to my Alvin? My little boy."

My uncle moved to New York after the war. I've told some of his stories to my children and to friends. As I tell them I become the third companion to Big Dave and Little Joe, riding around China

cutting off heads, the darling of the Shanghai whorehouse, or sailing to the next port in the Mediterranean.

In the late 1960s Uncle Dave died. By now I was in the garment business. I had a department in Bloomingdale's in New York. In California, I sold to Joseph Magnin, a chain of high-fashion stores. It was more than two decades since the days of the stories in my uncle's flat on Capp Street.

The garment business was doing well, but there were problems between my designers, and Sara Urquhart was recruited to make peace in the department. A few days after she joined the company, I asked her out for lunch at the Palm Garden on Market Street. We sat at the counter and I turned to her and said, "Sara, I know you came from Scotland but how did you get to San Francisco?" She told me about her jobs in London and New York and how she had come to San Francisco to open a high-fashion store. Then I said, "Sara, tell me about your home and your family."

One day, a few months later, I was in my factory and I got a call from Peggy, my receptionist. "Alvin, a guy here has a little store in the Tenderloin on Ellis Street and he wants to buy some dresses."

"Well, take care of him."

"He says he wants to see you."

"Peggy, I'm busy. Give him to Hal, he'll take care of him."

"Okay," she said, and hung up.

Five minutes later the phone rang again. "He really wants to see you."

"Peggy, everyone wants to see me. But I'm busy. Tell him to see Hal."

Nothing happened for about half an hour, and I forgot about the guy. Then Peggy called me again. "Where are you? He's writing a note and he wants me to bring it to you."

"I'm in shipping," I told her.

Peggy came downstairs and handed me a note. She watched me open it. It read, "Does the name 'Evad Niksud' mean anything to you?"

"Peggy," I said, "Please ask him to meet me in my office."

When I got to my office a little, older guy was sitting there. "Are you Little Joe?" I asked.

"Yeah, I'm Little Joe."

"I'm Nivla Niksud."

We went out for a cup of coffee. He told me the same stories. He told me they jumped ship in Shanghai when they were seventeen. He told me, "Your Uncle Dave had this thing with an older woman who was forty years old and had a beautiful house that was full of whores." He continued, "We went to Mongolia, we rode with a warlord, we barely got out alive. We went to Alaska together. We jumped claims and fought in bars. Your uncle beat up a lot of guys who didn't like Jews."

I asked him if they cut off heads in China. He said they did. We drank some coffee.

"What can I do for you, Joe?" I said.

"I'd like to come in and talk, but you're busy."

"There's always time for coffee. Come in whenever you want."

"And I want to buy some dresses. Like the ones you sell to Joseph Magnin. I sell mainly to men who like to wear dresses. And when they go to Joseph Magnin they can't try them on. In my store they can try them on."

"Sure," I said, "You can have anything you want."

Thomas D. Joseph, *Bodega Bay, Autumn*, 2006, oil on gessoed paper, 30 × 22 inches

You and I and Two Bottles of Beer

Glen Stephens

You who knocked at my gate last night
Come again tonight
I'll let you in and
You and I and two bottles of beer
Will sit on my front steps
And watch it all go by

All the boys in the neighborhood
With the girls from down the street
Will wave and call to us
As they pass beneath the moon
On their way to paradise

You'll play your guitar
And I'll sing a song
So sweet so full of hope and joy
Of laughter and love and happy days
From all the times gone by

That they'll stop and listen
And sing with us
In a chorus that will fill the sky
Until the stars fade
In the chill of early dawn

And the sun comes up
Warms the empty street
While you and I
Lie sleeping on the porch

Gretel

Joan Thornton

IN THE old days, bears were both persecuted and adored. Because they were persecuted I was naively on the side of those who adored them. Father, on the other hand, bragged that he would shoot any bear that invaded our part of the forest.

One afternoon, while gathering kindling in the woods, I saw a pair of adult bears strolling with their cub, their fashionably dressed, well-groomed appearance belying all my father had to say about the Ursidae family. The adults were bigger than I was at seven, and though I admired them I hid, not moving an inch until they strolled out of sight. Leaving my basket of kindling, I investigated the direction they'd come from and at length I happened across a cottage, a cottage finer than the one in which I lived with my brother, father, and stepmother.

I confess I picked the lock with the safety pin that kept my shirt closed. Inside, I could not believe my eyes, for I would have loved to live in a house so neat and well appointed. A pot of porridge was cooking over the fire and, hungry as I always was, I took a large ceramic bowl from a nearby shelf and helped myself.

When I burned my tongue, I dropped the bowl, and the contents splattered on the waxed floorboards. There were raisins, apples, and cinnamon in the oatmeal, and the tantalizing aroma was stronger than the burn. I filled a medium-sized bowl and let it cool while I wandered about the room, admiring a piano, sheet

Patricia Thomas, (top) *She Lived in Two Worlds*, 2010, pastel, charcoal on paper, diptych, 44½ × 60 inches; (bottom) *She Lived in Two Worlds (Negative)*, 2010, pastel, charcoal on paper, diptych, 44½ × 60 inches

music, leather-bound books, and three upholstered chairs set on an Aubusson rug. The porridge was now too cool, so I put some boiling porridge from the pot into the smallest bowl and mixed in what had cooled until it was just right. I admit to spilling milk and dribbling honey onto the rug as I made myself cozy in first one and then another of the soft, plump chairs. We had only hard chairs at home and not enough of those.

Honestly, I did intend to clean up my mess later. I never stopped to think that the bears might be on their way back. After all, I was only seven and I'd never before enjoyed such a breakfast. It made me sleepy. I wandered up the stairs looking for someplace to lay myself down, just for a minute. There I found real beds, not piles of straw as we had at home. I tried them all and fell fast asleep on the most comfortable one, the littlest one.

Everyone knows how I was caught. The bears identified me as Goldilocks, not Gretel, but it's understandable, I am a blonde.

Let me tell you, they may not have been the filthy animals my people said they were, but that Papa Bear was one mean son of a bitch, and Baby Bear was a little whiner sniveling into his mother's fur when he spotted me in his bed. I hightailed it out of there, right through the second-story window. I didn't mean to break the stained glass. When I realized I was being chased by Papa Bear in a green Packard sedan, I hid behind some brush until he passed.

By the time I got home, having taken the long way around, I was glad enough to see our cabin—until I spotted the Packard. Papa Bear, my father, brother, and my terrible stepmother were all having a loud squabble on our broken-down front stoop. My stepmother was yelling that I'd never been any good. Papa Bear was yelling lawsuit. Father, in a dither of ineptitude, was yelling that he didn't understand a word of the accusation, and brother Hansel shouted that they were all crazy and he was on my side no matter what.

I stayed hidden until Papa Bear drove off, roaring, "You'll hear from my attorney." When I went into the house I learned that my stepmother had made a decision. She made all the decisions. They could barely afford to feed me. The only thing to do was get rid of me. My father, who'd bragged only yesterday that he would shoot any bear on his property, now unmanned by his wife, hung his head and said, "What else can we do?" Hansel, that loyal fellow, said if they forced me to leave then he would go too.

Although it's a nice touch, storytellers invented that part about scattered breadcrumbs. We never would have wasted food that way. We ate the bread my father slipped us on the first day out. The hungrier we got the more we talked about all the wonderful foods we'd heard of but never tasted. Just short of starvation, we found the gingerbread house.

Textured with raisins, chocolate-covered walnuts, and persimmons, the gingerbread exceeded anything in our imaginings. Candied orange slices made the window frames. The windows were pure sugar, clearer than glass. Hansel broke off a peanut brittle corner of roof and was crunching away when a doughy lump of a woman opening the top of a white chocolate Dutch door invited us inside. It took little time for us to realize her hospitality hid an unfriendly agenda.

Inside the gingerbread house things were not as attractive as outside. The walls were covered with mold. Lines of ants transporting crumbs traveled along a sticky floor, and leaking vats of cream soured the air. There were also piles of children's clothing lying about, but no children. That the mumbling, muttering woman was a witch we had no doubt. As you may have heard, when the witch asked Hansel to climb into her newly lit oven to see if he could restack the firewood to draw more air, we tricked her into showing us how it could be done. I don't like to dwell on this.

Cleaning the gingerbread house as best we could, we took shelter and sustenance until the rains came and washed away what was left of the candied fruit, sugar, and flour. Having ruined my taste for dessert I was not sorry to see it go, and yet I had the saddest feeling that something magical in the surrounding forest was lost forever. Soaked and hungry again, we straggled back to our old home in the hope that our father had acquired a backbone.

We found him alone and miserable. Stepmother had taken off with a young mandolin player and Father was awaiting the court's latest ruling about the lawsuit, which had proceeded despite my absence. I felt remiss that I'd not been there to testify and would have gladly taken the stand. I *was* guilty of trespass after all.

The lawsuit had dragged on and on, with appeal followed by counter-appeal. At first Papa Bear wanted only an apology and his damaged window repaired, but a contingency lawyer convinced him all bears had been deeply insulted and he was therefore entitled to ask for much more, to whit, my father's property, which was contiguous to the bears'. In place of the usual hourly fee, the lawyers would receive land of commensurate value.

The opposition firm, persuading my father to countersue for harassment and alienation of affection, was also working for a portion of the award. Arguing that the bears had so terrified my father's two young children and his wife as to cause them all to run away from home, the lawyers garnered media attention and public sympathy. They promised that because bears live by forage and barter and not money, my father, if he won, could claim the bears' property.

Witnesses claiming friendship with my father, in return for the promise of an acre or two, testified as to the threatening, menacing, dirty, quarrelsome, undesirable character of bears. Father's attorney called the bears' charming cottage an "attractive nuisance" and insisted no blame could be put on an innocent child for breaking

and entering. Papa Bear objected, insisting the offense at hand was actually entering and breaking, but his self-assurance turned the court against him, for who likes to see a confident bear?

Before the court battles were over, brother Hansel, impatient with the lawsuit, left to join the navy and I was left to deal with the lawyers. Looking every inch the pitiable victim of bear belligerence, Father became a sickly shadow of the man he'd once been and I nursed him in his last wasting illness.

In taking over the household, I began to examine the details of the complex legal maneuvers that had so sapped my father's vitality. One could not help but notice the chummy relationship between the "opposing lawyers"; in fact, they were all first cousins. Even after my father's passing they managed to keep the lawsuit afloat "in consideration of the heirs."

The attorneys hotly argued that *I* was the primary owner of the property on which the alleged vandalism occurred. They claimed that, as my great-grandfather had loosely bartered for the property from an Ursidae, a proper survey of title must be conducted. Then a judge insisted that a price be attached to the land on which the litigants lived. This took months, as the appraisers could not agree. By the time they were ready to go to court again, I understood my father's frustrations and exhaustions. It had been nine years since I broke into the bears' house. I was sick of appointments, documents, reporters, and surveyors.

The last trial drew a large crowd. Newspaper photos showed Papa Bear standing tall and roaring at the defense attorneys as they harangued him with charges of maintaining an attractive nuisance, of leaving dangerously hot cereal within the reach of a child, of neglecting to aid an injured girl who had fallen from the unsafe height of his bedroom window. The papers showed me, a fair, blonde "orphan," looking wide-eyed and vulnerable.

My testimony, discouraged by my lawyers, was simple. When asked if I broke into the Ursidaes's house, I unfastened and showed the jury the very safety pin with which I had picked the lock. When asked if I burned my mouth on the porridge, I volunteered that indeed I had stolen the bears' food. When questioned about my fall from the second story, I expressed sorrow at having broken a pretty window made of colored glass and insisted that I'd not been injured. With each confession, my attorneys looked increasingly worried.

The jury, consisting of nine men and three women, took little time bringing in their verdict. The judge took even less time adjudicating. Although we won, almost everything was lost. Where my father's cabin once stood, trees are coming down and bulldozers flatten the land, which is now divided by string into buildable lots. The sounds of hammers and saws replace the calls of blue jays and crows, but I am told this is progress. It's terrible how something you did when you were only seven can have such a long-reaching effect. Terrible and fortunate, too, for how else could I have ended up with the Ursidaes's fine little cottage?

Sun Woman Triptych

Three Paintings Illustrating a Tomales Bay Miwok Story as Told by Juana Batista
Recorded by Ethnographer C. Hart Merriam in the Early 1900s
Paintings by Kathleen Rose Smith

Sun Woman Triptych (Print I), 1994, lino print, 12 × 12 inches
This piece represents the once-dark world at Tomales Bay, with a band of
white fog and a glowing Sun Woman far away in the distant east.

———

OLD MAN COYOTE hears of the beautiful Sun Woman who
lives in the East, and sends men to bring her to Bodega Bay.
When Sun Woman refuses to go with them, they tie her up
and take her back to the coast. Once Sun Woman is released,
she falls in love with the region near Bodega and Tomales
bays. Sun Woman is so happy that she shines like a bright
abalone shell.

Sun Woman Triptych (Print II), 1994, lino print, 12 × 12 inches
Sun Woman's face is represented here with chin tattoos; the ropes
that bind her with vertical and dotted (pulling) lines.

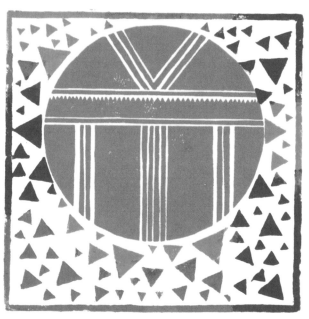

Sun Woman Triptych (Print III), 1994, lino print, 12 × 12 inches
Sun Woman's body, covered with abalone shells, gives off
so much light that it is hard to look directly at her.

I Know Three Things

Nancy Binzen

I know three things:
That which is will be.
That which will be was.
That which was is.

I dreamed I was awake.
The hair on my head grew grey
And the flesh sagged on my bones.
I turned on my side
Tucking into myself like a mother
Curls around her baby
And found another dream.

Yesterday my beehive erupted.
The old queen left with the restless ones,
Those who yearned for
A land just beyond the imagination.
Those who stayed will make a new queen
From the sweet nectar of their bodies.

Sometimes the Ancestors visit me.
They're always happy to come.
We talk about old things
To see if they matter any more.

Creating an Apian Society

Francesca Preston

HAVING A beehive on your property is a bit like leasing out land to a commune of ardent workaholics who don't speak your language. You get to pretend that you are a sort of caretaker, although you don't understand them.

We're not experts on our farm. We like to keep things simple, or at least funky. So when we stumbled across an old style of beehive called a top bar hive, we were attracted to its makeshift quality and built ourselves two out of scrap plywood. They're ideal for the dilettante with a junkyard, the urban activist with a rooftop, or the small organic farmer concerned by the current state of things (where have all the pollinators gone?).

Bees are not for the faint of heart, though, nor those lusting after much honey. And top bar hives are unpredictable and wonky. Basically, you provide the bees an empty box, which looks a little like a coffin, and about thirty loose bars on which to begin building their combs. There is no plastic foundation, as in the conventional store-bought hives, so the bees begin from scratch, as they would in the wild. A busy hive with a good flow of nectar can build a comb the size of a dinner plate (this seems to be a standard measurement among beekeepers) in a matter of hours.

And so, as the spring months went by, we watched our bees ("our" bees?) fill the hexagonal pockets in the comb with luminous nectar, purple and orange pollen, loopy pupa, and finally, wax-capped pods of perfect honey.

Jon Langdon, *Night Rose,* 2010, acrylic
and oil on canvas, 30 × 40 inches

Mysterious things happened. One hive became a ghost town. At the same time, a swarm was offered to us, and we scrambled to tease it out of a neighbor's tree. This second swarm didn't stick, either. We saw the arrival of a new queen in our "strong" hive, and wondered what fate—or her workers—had done with the last. The new queen somewhat resembled a potato bug: long and date-colored.

Then summer turned from hot to really hot, and a few combs fell from the hive's rafters. The bees, in their inexorable swoon of wax-carpentry, began immediately to mend each fallen comb by fusing it to its neighbor. The whole thing looked something like Gaudi, and I began to panic. This was hardly the perfect hive, with nice accessible rows of comb correctly spaced. Intervention seemed required. But whenever I spent too much time trying to straighten their combs, the bees made a crashing sound, all together.

I called my bee-mentor, a philosopher named Jonathan Taylor, who visited the hive and told me, "The bees are perfectly happy." It was a sunny day, and while we watched, dozens of bees were slipping through the entranceway of the hive, bright pollen bulging from the pockets on their thighs. Some were so heavy with honey that their bottoms hit the landing board as they descended. "The only one unhappy with the situation is you."

Apparently, the state of the hive depended entirely on who was looking. After that minor epiphany, things fell back into an unfettered order. The bees kept working, cleaned up, and even allowed us to take a single comb of honey from the hive. It felt like a gift, though that, too, might be delusion.

The honey, a dark ineffable sap, tasted a bit like buckwheat, sorghum, black cherry, and also none of those things. In the kitchen we cut small squares of comb and sucked on the juice, spitting out clumps of wax into our hands. We spoke the names of plants, trying

to find our way home through the honey. Coyote bush? Clover? My father thinks cover crop and hedgerow, definitely.

It's getting cold now, and the commune is quieter. The cracks in the hive have all been caulked with propolis, and the bees mass around the queen to keep her warm. All winter long they will eat from their own larder, and we will leave them alone.

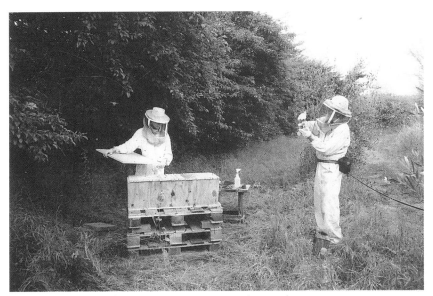

Susan Preston, *Lou's and Francesca's First Hive,* 2007, photograph

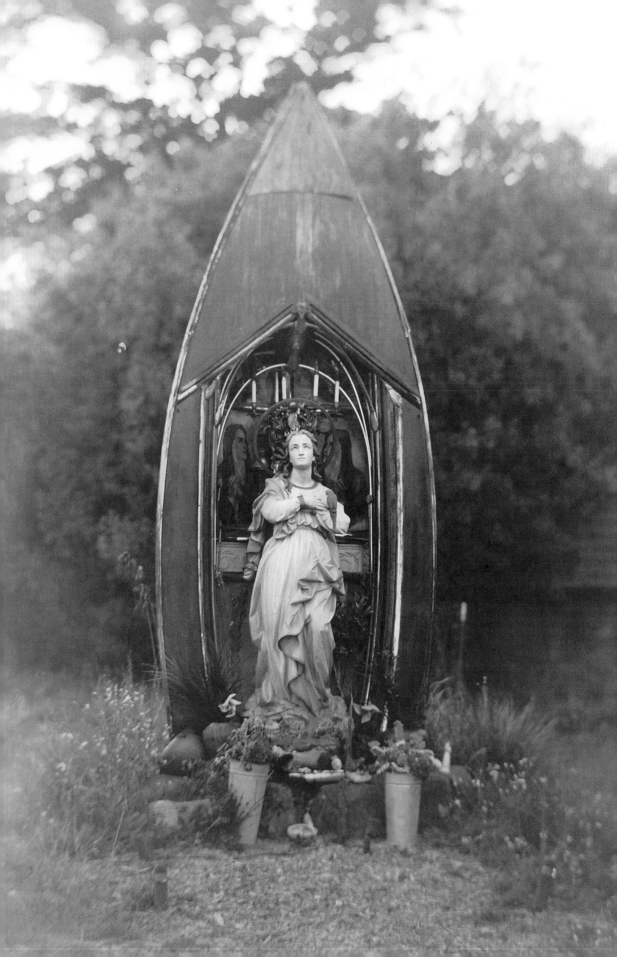

Jake's Memorial

Michael Parmeley

I WAS outside, sitting in my wheelchair, sipping my morning coffee, eating my morning bun, watching them arrive. I was next to the Inverness Post Office, in the shade of the Blackbird coffee shop's veranda, resting my coffee mug on the veranda's roadside handrail. Across the street, people were beginning to fill up the Inverness Store's parking lot. They came in ones, twos, or in groups. They came in trucks, cars, or on motorcycles. They brought buttons and slogans, their own brand of patriotism, attitude, and flags—so many flags.

I'm not normally a sentimental guy, but a tear may have escaped my eye. I looked around. I was pretty sure no one had seen me cry. I continued to sip my coffee and continued to watch.

They weren't local but they had a lot of local support. There were more than 200 when they were all assembled. They were colorful and talkative, more colorful and talkative than the flock of red-winged blackbirds that sit on the wire and face the setting sun every evening along the Levee Road.

They came to honor Jake Velloza, a local boy and young soldier who had died in Iraq two years earlier. On this day, the post office was to be dedicated to Jake and his name and his picture put up on the newly painted post office wall.

I couldn't actually attend the ceremony, which was held in downtown Inverness's Plant Park. Hidden by trees and as beautiful as it is, Plant Park is not wheelchair accessible. But the park holds more people than the post office does. They left the parking lot en masse,

crossed the street, and disappeared into the park. Their numbers could have been intimidating, their attitude, too, their clenched fists and their open hearts.

I heard them cheer when they first heard Jake's name. I can still see their flags flapping in the wind. I can still feel the vibration and hear the roar the motorcycle engines made as they climbed out of town afterward.

The event made me crazy for the following week. Maybe I'm always crazy. It's getting harder for me to tell these days. I've spent a lot of time since they left looking around downtown Inverness and I've noticed that, except for the new plaque hanging in the post office, nothing seems changed.

But I've changed. I'm a 100 percent disabled combat vet. I can't walk or even stand any more. Vietnam was my war. Inverness is now my home. I was ready, prepared. I expected them to arrive. I just had no idea that they would bring so many flags.

I think many who came to Jake's memorial were vets, too. We're a feisty group, we vets, very manipulated, very patriotic, and not inclined to cry.

Today there's a framed, glassed-in reminder of Jake and Jake's death and of his service to his country, hanging on that wall in the Inverness Post Office. Stop by if you get a chance. Look at Jake's portrait and into his eyes. His gaze might haunt you. It does me.

covenant
Gina Cloud

I shall not
pick you
until
I am ready
to eat you
and
I shall not
want
to eat you
until
you
are
at
your
best.

Cutting the Boys' Hair

Jody Farrell

THEY WERE beginning to look scruffy, she thought, the three of them. She noticed how the hair at their napes stuck out over the collars of their pajamas as they spooned cereal into their mouths and kicked at each other under the table.

"Haircuts today," she announced. "Everybody." They raised the usual ruckus, but she went to the bathroom and got the scissors from the drawer and the narrow black comb and the clippers. They hated the clippers, but she enjoyed the professional look of them laid out on the towel spread across the kitchen counter.

Hooking the tall stool with her toe, she pulled it into the middle of the floor to the wide space between the sink and the fridge.

"Okay, who's first? Step right up!" Steve approached, scowling. He was the oldest and knew he might as well get it over with. Also, he was twelve and beginning to recognize the disadvantage of scruffiness now that he was in middle school. She flipped open the torn white sheet she used as a drape. It smelled of soap and sun. She sniffed appreciatively as she pinned it around his neck, tucking the edges under his collar. She sniffed him appreciatively, too. She loved the smell of her boys, peppery, dusty, redolent of grass and sleep. She dragged the comb through his hair, ignoring his pained "Ouch!"

"Sit still, honey. Remember, first in, first out." It was summer, and haircuts were easy. They all wanted to look like the astronauts. Her hand slipped along Steve's warm scalp, scissors snipping the hair that stuck up between her fingers, trimming carefully around the

ears, and then the clippers taking the soft fuzz at the nape. She blew at the back of his neck and undid the sheet. "There you go, mister. Hey, how about my tip?" She caught his arm and pulled him close. He gave her a quick peck on the cheek and fled.

"Who's next, gentlemen?" She pointed the comb at Paulo, her adopted child of the dark eyes and dark moods. He ignored the summons. "Take Tom. I'm not ready yet." He had fashioned a catapult out of a fork and the rubber band from the morning paper and was launching Cheerios across the breakfast table. She knew it was no use arguing with him.

"Hey, Tom-Tom. Your turn." Tom was ready. He was always ready. She hefted his chunky little body to her hip and then to the stool. He made a grab for the scissors, but she anticipated it and handed him the mirror to hold instead. From the reflected surface his black eyes shone back at her from under his straight fringe of hair. This was her last child, born of an unwed mother in Hawaii and brought to the states for adoption, a little samurai who, snuggling on her lap after a roughhouse with his brothers, confided, "Mama, I am tough, but I still like gentle." His was the hardest hair to cut. It slid out from under the scissors like water off a rock.

Before she was through, Paulo was at her side. "When are you going to do me?"

"Did you pick up all those Cheerios off the floor?"

"Mo-om! I already did!"

"Good boy! Now take the bowls to the sink and put the cereal box away in the cupboard. Then I'll be ready."

Paulo's lip quivered. "I don't want to. That's your job anyway."

She looked at him and raised her eyebrows. He went to the table and picked up the bowls. She put Tom on the floor. "Okay, are we both ready now, Paulo?"

Paulo climbed on to the stool and submitted to the drape. "Can you cut my hair like Steve's?"

"Oh, honey, I'll have to cut off all your beautiful curls. Are you sure?" He nodded and she clipped. When she handed him the mirror, he scrutinized himself, turning his head this way and that, then nodded again and slipped from the stool.

"Wait! My tip!"

He smiled at last and offered his cheek.

She went for the broom. The day was growing hotter. She reminded herself to get the trash to the incinerator in the back yard. The county restricted burning after noon during the summer months. At her feet lay the results of her morning's efforts. Steve's coppery hair mingled with Paulo's brown tendrils and Tom's straight strands of black silk. She gazed for a moment. Then swept.

TOP Jonathan Aguilar, Grade 11, *I Try*, 2011, collage, 11 × 14 inches

The objective in this Art 1 assignment was to teach students about composition, informal balance, emphasis, and exaggeration. Adding text to the piece required Jonathan to consider font, content, and placement.

BOTTOM Hector Martinez, Grade 12, *Pride*, 2012, collage, 14 × 8 inches

In his Advanced Placement art class assignment, Hector's theme was immigration. He created a series of small-scale collages with Chicano symbolism. The fence, representing border politics, is repeated throughout the series.

—*Rachel Somerville, art teacher, Tomales High School*

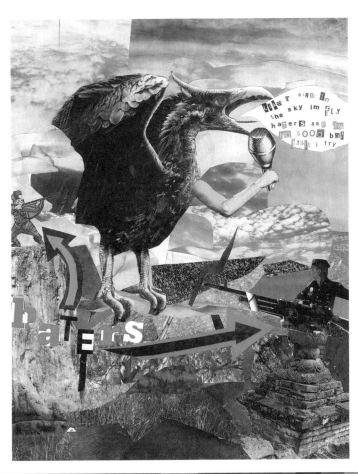

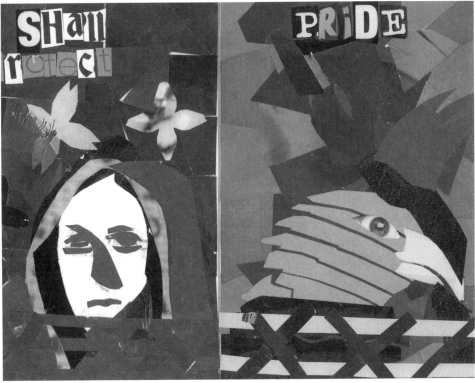

Sponge

Emily Cardwell, Grade 2

I feel wet.
I am angry because when I put towels on I stay wet.
I wish sometime I could stay dry for once.
I smell rotten food and it turns out I'm wearing it.

Plants and the Water

Lisandro Gutierrez, Grade 7

When the plants and the water meet the marsh they
are like in a happy family. Both families have a big
family party. They laugh and have a fun life. They
protect their family by poking humans with their
pointy grass tips. They repeat that until something
eats them or their life is over and they dry up.

Olivia Fisher-Smith, Grade 8, *Submerged*,
2010, gouache, 7½ × 12¼ inches

Something Severe

Frances Lefkowitz

THESE STRAITS were sticky, they would not go away. Her escape options included divorcing from everyone she knew, doing yoga and eating more broccoli, or starting a riot. Or, she could just throw another dwarf tantrum at whoever next provided a small irritation—the store clerk who should be smarter about counting, the dawdler who would better serve society by pointing her car to the nearest exit. She settled on operation blankness, though not smiling seemed especially heavy on her face, creating a repellent that further ensured isolation.

A note on the stucco wall said "WET." She stripped off the warning by its blue masking tape as she walked by, hoping a man or woman traveling this same route later in the day would lean against the building and smudge the shell, stain the jacket, so someone other than she would be imprinted. When a person is freckled so heavily, it is no dainty chore to lighten up. Having been stranded at a young age, she doesn't really know how to make herself feel better except by making someone else feel bad.

The dark was approaching and she was still downtown, getting and spending, but mostly dropping things, stubbing her toes. Oh, for an earthquake, something severe and potentially flattening! Instead, she fingered a slip of paper in her pocket, pulled it out. "WET," it said. She licked her lips, bought a smoothie, looked for more mois-ture in her vicinity. When framed by asphalt and elevators it was easy to forget that her city was located on an ocean. But she could smell

it in the air, faint as mice. She wanted, in a sudden crisp moment, to see waves. She had been smelling them her whole life but not inhaling, remaining dry. After months of meander, she was now racing through rush hour like a fish on fire, trying to get to the west-facing sand by sunset.

What she did not expect was corn dogs and lemonade, as if her city beach were a fair. This wasn't what it was like the last time she was here. Then, it boasted needles, rubbers, and broken bottles. You had to wear shoes to keep clear of them. Also, it used to be so quiet, not in the way that was comfortable but in the way that you couldn't hear "HELP" if someone screamed it. Now, in the twilight, bright carts tooted, telling the other wheels—bikes, trikes, skateboards—to scoot over. People in sweatshirts leaned against the high seawall, children tried to pull themselves up to glimpse the stretch of sand marching to the ocean, bossy with waves.

It was too cold to wade in the water. Instead, the sea waded into her, evaporating into salty moisture, penetrating her skin, curling her hair. She was thirsty but had no more cash. She stuck out her tongue, hoping to catch some of those ocean particles. Now, instead of an earthquake, she wished for fog, water floating in air. That would be the easiest way to get wet right here, right now. An easy wish. Maybe that was the best option: find something that comes to you naturally and wish for it just before it gets there.

Leslie K. Allen, *Limantour Estero, Pt. Reyes, No. 2 (Dune Grass)*, 2011,
oil on maple panel, 48 × 48 inches

untitled, loss and what comes next

FOR DAVID GAINES

Monte Merrick

forget all these cares: the rising seas, the dying
 seas—the lost grasses of california and
 fortunes falling down like skatepunks on
 the half pipe—a bag of bread tied to the
 belt loop and hop the back fence.
i mean it.
this world is getting tired of asking nice—thinks
 it's high time the 7-11 closed.

scour our teeth with salt.
wait for these lenses to return.
we love a barbed wire fence—a white plastic bag
 whipped in the wind.
the cameras are rolling—meteorites hiss to the sea.
find the last pinkening dusk and wade across.

oh, sure, we all have to die sometime—*take the last
 train to Clarksville*—and lay down in wine-
 soaked dust.
there are no queens—and the kingdom is a piece
 of junk.

i've stood at the wide open window—four a.m.—
 and watched venus rise with the last
 quarter moon.
the sun is just behind those sunburned hills.
the old woman is young and turning this way.

think of the mowed corn as well as that tinkling
 bell circling our house each night—then i
 thought it the ghost of one of many dogs
 i've found and lost—sam, who was with us
 for less than a week—tore the stuffing out
 of my stepfather's front seat.
i can't remember where he went after that—we
 came home to find the books unshelved,
 some half eaten, and shit on the floor.

now i recall that long ride from home.
my mother opens the door—shoves sam out—puts
 it in drive, and we leave him to rust.
she says we're setting him free.
out the back window i watched him watch us leave,
 black and white dog in the center
of that road, gravel and carved through the flatland
 and oaks—laurel in bloom.

sometimes we find newborns, sightless, pink and
 doomed, alive beneath tires dumped in
 the arroyo—most of these tires will never
 be moved.
the wind kicks hard as the sharp moon slips
 beneath the ribs of these mountains, rising
 from the bay.

i'm glad for dexterity and the texture of skin—
 and the barn owl that floats above my head
 while i piss.
how she speaks in my tongue as she lands at
 our door.
i'd like strong water to rinse me as it clatters and
 glides down the slope—i want to be clean
 before we reach the shore.
i want to walk on my feet into the next world.

Candace Loheed, *Birds of a Feather*, 2011, mixed media, 12 × 18 inches

The Year My Nouns Left Town

Helen Wickes

When you ask how I mind aging, you mean
losing my looks, but I had no looks to lose. They
 lived
in the eye of the beholder, not the beholden.

It's my nouns I miss. I used to plunge into sentences
like a diver into cool, deep, green water.

My words have gone missing. I hover at the edge,
staring down. There's dust and ashes. Punishment
for devotion to language, not body. But every word

has a body, comes with its own smell, texture,
 way of walking,
how it wants to be held and clothed. You get
 embarrassed for me.
I am not embarrassed, I'm merely lost.

I've lost my nouns—my doers, my done to's—
 I've swallowed
my things of speech. You say, *Find words for
 absence*, but I can't
find them either. Blame this on my *harmonic
 imbalance,*

coupled with *deprivation* of my *Estragon*, but he
　　was a character
in a different play. So I try *my estrangement* or
　　estuary, arriving
at *estrepe*—the violence of aftermath. Finally I
　　stop calling

for objects and the glue binding them to me, me to
　　you, and float
in the synapses—spacious and nameless—between.

Claudia Chapline, *Four Calligraphic Images*, 2011, Sumi on paper, 8½ × 11 inches

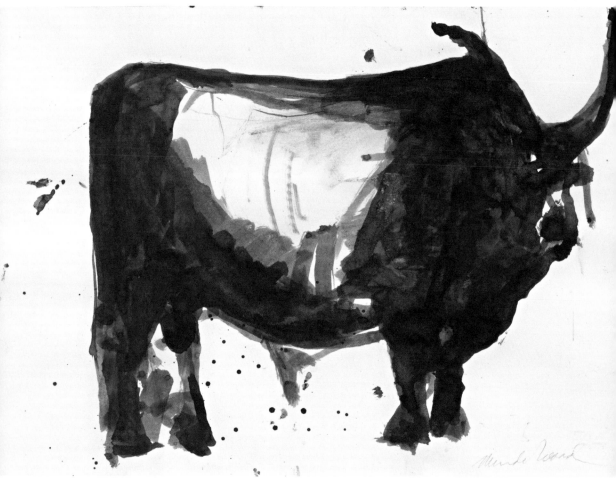

Mardi Wood, *Maremma Bull,* 2010, China ink, burnt sienna, Fabriano paper, 19 × 13 inches

About Bunin

Susan Trott

Ivan Bunin, 1870–1953, won the Nobel Prize for Literature.
His biography, About Chekhov, The Unfinished Symphony, *was published*
in English by Northwestern University Press in 2007.

BIG.

How full of disdain I was for that word. Bunin smiled to himself. Chekhov, my Antochka, however, seemed to relish it, seemed to delight in its apt discovery. But I, twenty years old, ten years younger than he was, full to the brim with the egotism of youth, in my mind patronized such a paltry adjective to describe the sea, while far better words coursed through my mind how *I* would describe the sea. For instance, how beneath its glittering serenity lurked *the lassitude of death.*

No, too gloomy. Even way back then I had to turn away thoughts of death that plagued me all my life and still do. No, instead I should have expostulated as Cyrano did when descrying Valvert's description of his nose as merely big: "You are too simple. Why, you might have said—Oh, a great many things! *Mon Dieu,* why waste your opportunity?"

But! Bunin remembered, I was also cowed at the time because he was Chekhov, and if he believed the word "big" to be descriptive, I was on the wrong track entirely. I would like to write in my book how I trembled in his presence at that first meeting, in Yalta, at the edge of the Baltic. I'd been waiting hours for him to pass by. It was

not a chance meeting at all, more like what they would call a stalking. And then I would like to tell how he sat and talked to me with the utmost friendliness, his eyes shining through his pince nez, so genuine and modest.

He asked me to come see him the next day at his villa and then, as we continued to talk, sitting on that wall, overlooking the sea, how dismayed I became that this conversation, going on so long, might replace the next day's invitation. Why meet this young man again so soon, he would think, and be bored anew?

Bunin sighed. But, to add all this to my book would be to write not about Chekhov but about Bunin.

And I did go to see him the next day and many days there-after in the years to come, days and nights and weeks and months together as we became the best friends in all the world, brothers, or sometimes just like father and son.

"Bunin, why are you sitting there dreaming when you have this book to be writing? Here. I've made us some tea. No croissants today. Day-old bread. I do the best I can for my grand old Nobelist, starving as we are. Well, ha! These ancient bodies don't need much sustenance to shuffle from one room to the other, eh, my darling? Do you hear what I'm saying?"

Shuffle? It was she who went out to the shops, going far afield in Paris *arrondissements* to find the best prices, then home to mount the four flights to their attic rooms—not a shuffler, his Vera, a mountaineer!

Bunin nodded, not speaking, since she was the deaf one if she would only admit it but, as deaf people do, she filled the air with her own voice so as not to fail at hearing his.

But he spoke anyway, if only to himself, "I haven't seen Antochka for fifty years and he is forty years dead. He never took care of himself, while I cosseted my every ailment real or imaginary.

He never even mentioned the tubercles that tormented him, never doctored himself while so busy healing others. He didn't seek out the warm dry climes. He…

"Oh, this is stupid, Vera, this and all these bits of his profound thoughts, these accumulating scrap-piles of brilliant quotes." He gestured around the apartment, scooped tatters of paper from the pockets of his robe and flung them into the air, where a ray of sunlight through the window illuminated the dust and silently captured the falling papers seeking out their brother and sister piles. "His words have already been read a thousand times and will be a thousand times more. What can I say that's new? I didn't know him, Vera. Russia didn't know him."

She replied as always with her incantation, which was marvelous, but at the same time incredibly annoying: "His sister wanted you and only you to write this book. Now, before you die. She asked you fifty years ago. This is your task. No excuses. You created great characters in your own stories. Now create him. Chekhov is in you, in your brain and heart. Stop dithering. Read to me something you have already written that you like."

Bunin read to her while she dozed beside him, making some small corrections as he did so, thinking, it's always good to read aloud to Vera. She helps me focus. I am eighty-three years old. I…

"Hail, lonely old age; burn, useless life!" Chekhov had written to Suvarin upon turning thirty. Thirty! Bunin snorted, then laughed. Well, come to think of it, Chekhov really was entering his old age, since he died at forty-four. His twenties were his middle age.

At his laugh, Vera twitched, but slept on.

"Chekhov esteemed his talent for jokes," Bunin read on aloud to himself from his book that balked at being completed, "and esteemed those who understood them quickly. Yes, it is a most telling sign, Chekhov often said, for if someone does not understand a joke, he is

a lost cause. Everything is simple in life, he said, rejecting in litera-
ture all that was artificial, skillfully arranged, and calculated to amaze
the reader."

There was a knock at the door. Bunin struggled out of his
armchair, knotted the sash around his robe, under which he wore a
suit over a white shirt, around his neck a paisley silk scarf. Stumbling
over piles of books, but instinctively knowing his way through the
maze, he soon made it to the door.

"*Bonjour, mon ami.* Welcome!" They embraced in the French
manner, kissing both cheeks, and proceeded to talk in the language
of the country. (Antochka had said, "I speak every language except
foreign ones." He must remember that for the book.)

"Come to the other room. We'll leave Vera to her little snooze.
Will you have some coffee? Some wine?" wondering if either were
at hand.

"No thank you. I have just eaten. I am replete."

As usual, his friend was encumbered with a bag of food and
wine and the fresh croissants denied them by Vera's scant purse. He
set it down, asking, "How is the book going, my dear?"

"It goes. It goes."

"I won't ask how you are for fear you will tell me."

"Yes, my laundry list of afflictions pertaining to my decrep-
itude always fails to amuse you, or anyone, but do you know,
for the first time in my life, probably, I feel I no longer inhabit my
body. Only my brain. My mind is so steeped in this book. Tell
me, although this has little to do with anything, how would you
describe the sea?"

"The sea and I have nothing to say to each other. I don't believe
it has entered into any of my stories. Rivers, yes. For the sea you
must go to Conrad. I don't believe you Russians have had much to
do with the element in your own stories, come to think of it." He

laughed and shrugged. "It is an alien world and a damned watery one. How can we begin to understand it when we can barely grasp a tittle of our own earthen one?"

Bunin felt his mind begin to wander again, which he would regret later, as he loved his conversations with his friend (as Antochka had loved the man's stories), but Antochka was ever in his mind and his mind was sorting, sorting....

When he awoke, he was alone, but he must not have dreamed the visit because Vera was rustling through the bag of nourishments, exclaiming at the wad of francs she found at the bottom of the bag. Thus did their friends keep them going in their dreadful poverty.

"Who has come? Why didn't you wake me?"

"Our dear friend, Guy.... No, wait..."

"Guy? Who?" She put her ear next to his lips, pretending to smooth his robe, but really to facilitate sound. It was still quite a pretty ear, he thought, and there were still one or two glints of red in the snowy waste of her hair. He remembered one of his young mistresses asking him once, what color was your hair? and how surprised he'd been as he still believed it was richly colored. It had turned white behind his back.

"Why, I believe it was De Maupassant," he said. "But...no..."

"No is correct. The man died fifty years ago. He cut his throat, or tried to, and they put him in an asylum. My God, what an end!"

"True. True. I must have been dreaming of Guy. He was Antochka's age when he died, only forty-two or forty-four. Maybe that's why I dreamed of him. I have been thinking a lot about death."

"You have been deep in those thoughts since I've known you. This is not new. Look! Here is an entire roast chicken. We will dine royally tonight. I will put it together with some potato I have."

"Is it day-old potato?"

"Potatoes have no age."

Women, no matter how intelligent, don't understand jokes, Bunin thought. I must add that to the little bit I was writing about humor before whoever it was, dead or alive, knocked on the door.

"But, Ivan, who is it that came and brought these delicacies? Some *émigré* friend no doubt."

"I'm sure he was French."

"M. Gide? No, he died a few years ago."

"Did he slit his throat, too? If not, he should have."

"Why do writers die so young and so violently?"

"The English ones don't. It must be the tea."

At night, in bed, they held each other close, mostly for warmth until the sheets shed their cool, but partly for love. Vera fell asleep first, then Bunin, his mind finally emptying until only chunks of thoughts and ideas were left burning, then coals, finally embers, so that he felt himself drifting off, his mind gloriously free of every thought, only images, silly images of dreams to come, wavering ones. The trick was not to focus on any particular image, as that would alert his mind once again.

Later, perhaps toward dawn, he awoke with an elephant standing on his chest, unable to move, to speak, but he must have cried out because Vera was awake and leaning over him, her eyes wide with fear. The pain! The pain! Yes, Antochka was right about everything—life, love, death, truth, beauty, the elephant on his chest, how simple they all were, no flourishes....

He was right, he tried to tell Vera. Everything is simple, Vera, is big. Everything of any importance, if anything is important...is *big*.

Pam Fabry, *The Shape of Things*, 2011, mixed media, 22½ × 29 inches

Salihah Moore Kirby, *spirits on the afternoon ship awake from an important nap-dream,* 2011, watercolor, approximately 6½ × 5 inches

Collecting

F. J. Seidner

I AM a compulsive, though selective, gatherer of objects, a sort of human magpie. I am obsessed with acquiring things I regard as interesting, unusual, rare, or beautiful and spreading them about. I have absolutely no need and very little room for any more such objects, but I am equally certain that I shall be unable to resist the impulse for further acquisitions.

Whole libraries have been written about the history of art, and vast tomes exist describing the wonders of specific collections, but relatively little serious scholarly attention has been paid to collectors themselves. Who are these curiously afflicted individuals who are drawn to collect? What are their attributes and motivations?

Despite the fact that key elements of Freudian theory are largely discredited, perhaps a glance at the insights provided by the psychoanalytic community is in order, particularly since Freud was himself an avid collector. The patient lying on Freud's famous daybed saw on the wall to his left an Egyptian mummy portrait and a copy of a Roman frieze depicting Gradiva. Antiquities of every size and description filled the room as well as all the other rooms of his apartment.

Although I am reluctant to penetrate the psychoanalytic view too deeply, as so much of it seems to deal with bodily functions, we learn, not unexpectedly, from Werner Muensterberger, a New York psychiatrist who wrote in *Collecting, An Unruly Passion*, "The typical collector represents an 'anal type.'" In addition, he argues that

objects, be they a doll or merely a thumb, give a child relief from distress, and this sets a pattern for later life.

As in other areas of life, money is a necessity for most forms of collecting but is not everything. In fact, in collecting the situation is sometimes reversed. If the collector's supply of disposable funds is too ample, the gratification accompanying a new acquisition is likely to be diminished. A purchase accomplished too easily, in other words, erodes the thrill. Thus, a central part of the collecting experience involves testing the limits of what is financially feasible, rational, or acceptable. The most prized items in a collection may equally be those that were a "find" or bargain or, conversely, those that represented a significant sacrifice.

Precisely what prompts our contemporaries to pay extravagant sums for works of art—items that produce no direct financial returns—is difficult to nail down precisely, since motivation varies with individuals and circumstances and is seldom without complexity. High on the list are such matters as social prestige or one-upmanship, financial speculation, calculated hedges against inflation, tax gambits, and the like.

Personal—or sometimes commercial or quasi-commercial—publicity is probably an even more important motivator. It is not uncommon for an attention-seeking collector to pay more than is required to obtain a work in order to win some notice for himself. Liquor dealers regularly spend some absurdly high sum buying an ancient bottle of Mouton Rothschild or Petrus at auction. They remain quite untroubled by the fact that the wine is almost certainly undrinkable, since their intent is not to savor the wine but rather to savor the publicity their profligacy will gain them in their local newspapers. A few months after the purchase the bottle is quietly returned to the auction house so that some other merchant can use it to the same advantage.

Seen from the pristine vantage point of pure collecting, motives and practices such as these are naturally regarded as vulgar. A principal defining characteristic of the true collector, on the other hand, is that he is driven by an urgent but narrow passion and desire to possess the works themselves, not by any tangential benefits that may flow from them. There are a number of other attributes commonly found among serious collectors. These are not necessarily universal, nor are they restricted to collectors alone.

Collectors tend to be romantics. They fall in love with paintings, with antique automobiles, with butterflies, with old silverware, and with countless other items. A collector in love is much like an infatuated teenager. If someone else has discovered or purchased the object of his desire first, or beat him out at auction, he is as desolate as a youth whose beloved has left him for another.

Confidence and expertise are important hallmarks. The serious collector is almost always knowledgeable about his field. Not infrequently, the depth of his knowledge in his specialty rivals or exceeds that of dealers, curators, or academics. Equally important is the notion of discrimination: the objects the collector is after must meet the standard of quality he has set for himself.

For many collectors, the thrill of the search exceeds the satisfaction derived from actual possession. To the lustful eye of the collector, the object he covets attains a subjective value inversely related to the ease with which it can be acquired. That is why a collector may be driven crazy when he enters a gallery and sees red dots alongside works of art. He is certain that the only desirable items are the ones that someone else has already bought and are therefore unattainable. For a collector of this temperament, the excitement is in the hunt, the pursuit, the discovery, the negotiation with the seller, the challenge of closing the deal on favorable terms, the strategy employed at auction, the victory over a competitor, and so on.

Dealers as well as auction houses thrive and play upon the need of collectors to outdo each other. The zest of battle seems to invigorate collectors and causes some to pay many times the real value of a work in order to keep it out of the hands of a competitor.

At some point competitiveness may shade into fanaticism. Fanatical behavior among collectors is not limited to reckless spending. Collectors will seemingly do anything to fill gaps in their collection or outwit competitors. This desire can also lead to unethical or illegal activity. Museums as well as private collectors routinely buy material they know (or suspect) to have been illegally smuggled out of archeological sites. Or, to take another sort of example, J. P. Morgan is reported in Thomas Hoving's perceptive work, *False Impressions,* to have arranged the manufacture of sophisticated copies of Medieval treasures lodged in European churches or private collections. He would then have his agents surreptitiously swap the fakes for the real articles, which would become a part of his own vast treasury.

This sort of single-mindedness is not infrequently accompanied by a contempt for institutions the larger society regards as positive and beneficial. Many collectors despise museums, for instance, because their purchasing power raises prices and permanently whisks coveted items off the market. These collectors lament as the objects they so crave are imprisoned forever behind glass cages for the benefit of vacant-eyed Philistine hordes, or even worse, stashed away in museum cellars or storerooms, never to be seen again.

Collectors tend to fall into one of two categories, which, for want of a more felicitous terminology, I shall call selectors and accumulators. Selectors seek out objects of quality and of a precise and delineated character. Collecting, for the selector, is a means of expression, a way of assembling a limited grouping of material in such a way that, when taken together, it reflects his taste, sensibility, and individuality. For

the painstaking selector, putting together a collection can be as creative and satisfying an act as actually producing a work of art. A collection so assembled is marked by a perceptible discipline and cohesiveness. Perhaps the most renowned collector of this type was Noah, he of the ark, who accomplished something few collectors ever do: he assembled a complete set of what he was after.

Among selectors, a carefully formed collection has a perceptible theme, though this does not mean that the collector must stick to a narrowly defined subject matter. Some of the most urbane and

Marnie Spencer, *Gullible's Travels,* 2008, acrylic, ink, and pencil on canvas, 15 × 12 inches

impressive collections are highly diverse and eclectic in nature, yet still possess a unique flavor and internal consistency reflecting the identity of the collector. The items within are joined by a conceptual or aesthetic glue, an invisible adhesive that causes the whole to become more than the sum of its parts.

Eugene Thaw, formerly a New York art dealer, is a good example of a collector who selects rather than accumulates. Thaw, who now lives in New Mexico, has formed distinguished private collections of old master paintings and drawings, American Indian art, and architectural models, among other things. He looks for what he calls the "aesthetic center of gravity" in the artworks he collects, the characteristics that enable him to group them so that all of them are visually enhanced. His satisfaction comes, Thaw told *Architectural Digest* in June 1996, when he "can take beautiful objects and somehow impose order on them, somehow bring them together in a way that makes sense of the past."

An accumulator, though indisputably a collector of sorts, is an entirely different sort of individual, with totally different aspirations and appetites. Although equally driven to possess, the accumulator is impelled by some inner need to collect in quantity. William Randolph Hearst, who indiscriminately imported the whole contents of chateaus, was unquestionably a prototypical accumulator, but many other examples can be cited. Here is an item that appeared in the *New York Times Sunday Magazine* on November 19, 1995: "Mitchell Wolfson Jr., whose family made millions through an entertainment conglomerate, has spent nearly his entire life accumulating some 70,000...well, *objets*. What to do now? Charge admission. The $10 million-plus Wolfsonian museum...in Miami Beach [contains] Wolfson's eclectic collection of items dating from 1885 to 1945, including the first Scotch tape dispenser, a Braille version of *Mein Kampf* and King Farouk's matchbook collection."

If an aesthetic or conceptual adhesive exists that brings cohesion to the first Scotch tape dispenser, the Braille version of *Mein Kampf,* and King Farouk's matchbook collection, I fail to perceive it.

Some accumulators confine their collecting to a single field, but their acquisitions may be characterized by bulk purchases rather than painstaking choices. In her historical novel, *The Volcano Lover,* Susan Sontag uses a hunting metaphor to help draw the distinction. Writing about Sir William Hamilton, the fanatical collector who served as British ambassador to Naples during the last three decades of the eighteenth century, she notes:

> *To collect is to rescue things, valuable things, from neglect, from oblivion, or simply from the ignoble destiny of being in someone else's collection rather than one's own. Buying a whole collection instead of chasing down one's quarry piece by piece [is] not an elegant move. Collecting is also a sport, and its difficulty is part of what gives it honor and zest. A true collector prefers not to acquire in bulk (any more than hunters want the game simply driven past them), is not fulfilled by collecting another's collection: mere acquiring or accumulating is not collecting.*

Buying a whole collection may be an inelegant move, but selling one is not equally stigmatized. Resourceful individuals, having assiduously formed a distinctive collection, will sometimes sell the entire thing at a handsome profit and move on to an entirely new field. The formers of such sellable collections are normally, of course, selectors rather than accumulators.

At its best, collecting can also elicit enormous joy, for it can make one the happy possessor of a stirring part, albeit usually only a very tiny one, of some brilliantly creative civilization.

Refurbishment: Rain on the Way

Calvin Ahlgren

The rowdy flock of robins is savaging
Pyracantha berries near the fence row,
having at it like there's no tomorrow.
They gorge, their yellow beaks agape
in misty sunlight, cackling and skrawking
to hail the approach of rain
in this stub-end weather front.
It's just a tryout for true spring's sly grope
easing across the fields.

This false refurbishment is harbinger for when
the real thing knocks us giddy with delight,
no less transported than the birds
and just as sense-fried as they get to be,
once the orange berries have fermented
to boozy joy inside their brick-red bellies.

Under the sign of the Tiddly Robin, tomorrow
truly is irrelevant. Faith and winter-grief avow
we'll have the showers, and then abundant sun,
while some of us ground-dwellers slog through
darker complications than the birds' hoochy euphoria.

Is their indifferent trust in what will be,
so different from our own pet illusions—
the ones that hunker and skulk
where the past keeps festering,
that predator crouched above its kill,
insisting in its silent way
that something compensate the waning day?

Jan Langdon, *Red, White and Black*,
2011, fiber/tapestry, 9½ × 11½ inches

How Rep. Phillip Burton and a Magic Marker Hijacked Tomales Bay into the Golden Gate National Recreation Area

George Clyde

I HAVE a home in the town of Marshall. The town is a strip of about thirty-five homes and businesses along Highway One on the east shore of Tomales Bay, in the rural unincorporated area of west Marin County, near Point Reyes. About fifty people live in Marshall, mostly in small cottages at the edge of the bay.

Tomales Bay is approximately ten miles long and averages a mile in width, sitting directly atop the San Andreas Fault. One of the most pristine estuaries in the world, the bay is home to the famous Hog Island Oyster Company, which grows shellfish in its waters.

Marshall is greatly loved by those of us who live there and by the tourists who enjoy the scenery and the oysters. But it is not of much national importance. So I was surprised to learn that in 1980, President Jimmy Carter signed a law adding this sentence to the laws of the United States:

> *For the purposes of this subchapter, the southern end of the town of Marshall shall be considered to be the Marshall Boat Works.*

You might wonder, Why did Congress enact a federal law to define the southern end of the town of Marshall? It's a good question, especially since there is no other reference to the town of Marshall

or the Marshall Boat Works in that subchapter or in any of the other laws or regulations of the United States.

The law was part of 1980 legislation expanding the boundary of the Golden Gate National Recreation Area. When I asked senior officials and rangers at that national park to explain the reference to Marshall and what it means, they had no idea. It was a complete mystery to them.

I came across this little mystery when I was trying to solve a bigger one—what is the legal boundary of the GGNRA, and does it include Tomales Bay? That question is important to me because my home rests on stilts above the bay and I have a mooring on the bay. Do park laws apply to me or not? And the question is important to boaters, to kayakers, and to the park, whose rangers cruise the bay in patrol boats enforcing park regulations.

As a retired lawyer, I decided to look at the 1980 law that established the park's northern boundary. That simple research project tumbled me into the fast-and-loose world of the late California Congressman Phillip Burton, where I learned an astounding secret about the park boundary and Tomales Bay.

PHILLIP BURTON AND A MISSING MAP

Burton served in the House of Representatives from 1964 until his death in 1983 at age fifty-six. His passion for the environment, his pursuit of power, and his unorthodox maneuvering helped put millions of acres of wilderness and park properties under federal protection. But his laws had a few rough edges—like the peculiar reference to the town of Marshall. And, as I learned, Burton, too, had a few rough edges.

"Nobody is perfect—certainly not the late Phillip Burton," California historian Kevin Starr wrote in a comment on John Jacobs's book, *A Rage for Justice: The Passion and Politics of Phillip Burton.*

Starr went on, "Congressman Burton loved power and pursued it egregiously. He had a terrible temper. He was sometimes hasty and imprudent. Yet he was also a great legislator: great in his vision, great in his defense of working people, great in his passion for the environment. Few members of Congress have wielded his influence or left behind the legacy of this towering, tumultuous parliamentarian."

In my research, I discovered how Burton wielded his influence to bypass the law.

In the late 1970s and early 1980s, spurred on by local environmentalists, Burton aggressively pursued expanding the GGNRA boundary to include properties that were still undeveloped. The federal government would acquire these properties for the park and protect them from development for vacation homes and tourist businesses.

As a result of Burton's efforts, President Carter signed the 1980 law expanding the national park boundary. According to the law, the boundary is shown on a map entitled "Point Reyes & GGNRA Amendments, October 25, 1979." So the map would show whether Tomales Bay is within the park boundary or not.

But the map was missing. It should have been on file at the Department of Interior's Washington headquarters, but it was not. Nobody knew where the map was or what had become of it. Some doubted the map ever existed. The law requires that the map be on file and available for public inspection at National Park Service headquarters in Washington. I placed a number of calls to park service officials in Washington only to learn that they did not have the map there. Nor could they find any record of ever having received it.

Surely, I thought, someone had to have a copy of the official map that Congress adopted to describe a national park. A simple telephone call to the right person in the right office should end the search.

The Washington staff suggested I check with the Park Service's Harpers Ferry Center in West Virginia, which designs NPS maps for publication. That office also had no knowledge of the map; they sent me to the NPS Denver Service Center, the federal agency's repository for maps.

Until that point, I had been looking for the map quite informally. But the Denver office considered my simple request for a copy of the 1979 map a Freedom of Information Act filing. Unexpectedly, my search had become official government business. The FOIA request launched a cascade of formal searches that extended to the park service's Western Regional Office in Oakland, to the GGNRA headquarters in San Francisco, and to the GGNRA archives in the San Francisco Presidio.

MADLY SEARCHING FOR THE MISSING MAP

"We have practically the entire NPS searching for the maps and have pretty much come to the conclusion that they don't exist!" wrote Susan Ewing Haley, GGNRA park archivist, in an email that went to ten current and former park service employees involved in the Freedom of Information Act search for the map.

As a lawyer, I was astonished. How could Congress pass a law for a national park and refer to a map that did not exist? But Susan Ewing Haley's startling conclusion was echoed by the Park Service's real estate staff—officials who needed to know the park's exact legal boundary. Greg Gress, Chief of the Land Resources Program at the NPS regional office, wrote me in an email: "Regarding the GGNRA/ Pt. Reyes map, what I'm suggesting is that, despite what the law said, the map was never created and therefore isn't on file here or in D.C. I'll double check next week with our cartographer to make sure about this, but if it's the map I'm thinking of, it just doesn't exist, or if it ever did exist, it has been lost both here, at the Park, and in D.C."

The skepticism within the agency only spurred me on.

A break in my investigation came during the Freedom of Information Act search when the Park Service consulted Douglass Nadeau, former Chief of the GGNRA Division of Resource Management and Planning. Nadeau was Burton's primary contact at the park during the 1980 boundary expansion. Now retired, he shed light on how Rep. Burton handled legislation in those days and provided hints about what may have happened to the map. He wrote in an email:

> *Every time Phil Burton was inclined to expand our boundaries he asked me to prepare a down-and-dirty map outlining the proposal according to his directions…with the proposed additions and text depicted with Magic Markers. They were usually dated by me and signed by Phil. These were the maps that were referenced in the new legislation—very unconventional but it was the way he wanted it.*
>
> *To correct this irregularity, the Denver Service Center should have followed up with an official, numbered, reproducible map. My sense is that in most cases this did not happen.*
>
> *If any of those original maps made their way back to my office, they are in the [GGNRA] archives.*
>
> *Unfortunately, I seem to recall a conversation with Bill Thomas or one of Phil's aides when they said that the last time they saw those maps they were rolled up on the floor under a couch in Phil's office! I wish I could offer a more promising lead.*

It now seemed likely that the 1979 map probably did exist in some form at some time. And Nadeau's email had all but confirmed

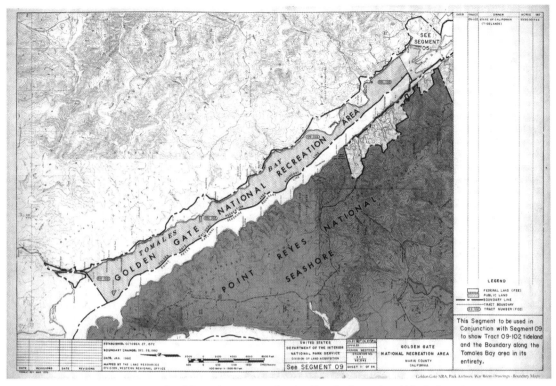

FIG. 1 GGNRA map dated December 28, 1980 showing Tomales Bay to be within the boundary of the Golden Gate National Recreation Area. MAP COURTESY OF GGNRA ARCHIVES

something else: it was he who created the elusive map. Moreover, the map, if I were to find it, would be hand-drawn with Magic Markers.

A TATTERED MAP

While the park archivists assured me they did not have the missing map or any copies, I was encouraged by what Nadeau wrote, and I decided to visit the archives to take a look myself.

The Golden Gate National Recreation Area archives are housed in an old building at the San Francisco Presidio that stands in the shadow of the entrance ramps to the Golden Gate Bridge. It was originally a cavalry stable that once housed up to 100 animals, mostly mules. Now it houses about four million documents in a clean and efficient area run by a friendly and helpful staff.

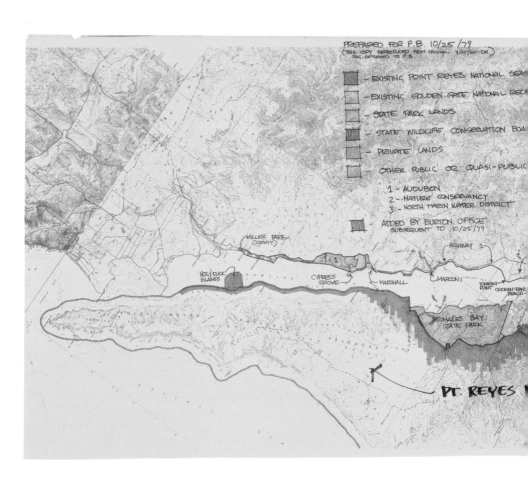

There, I reviewed a set of old park boundary maps dated December 28, 1980. Park Service cartographers had drawn these maps several months after the law was passed. According to those maps, the answer to my question was clear: Tomales Bay (sometimes referred to as the "Tomales Bay Tidelands") was within the park boundary. A legend on one of those maps is unequivocal:

> NOTE: THE GOLDEN GATE NATIONAL RECREATION AREA
> BOUNDARY INCLUDES ALL THE TOMALES BAY TIDELANDS
> FROM THE GIACOMINI RANCH TO PRESTON POINT EXCEPT
> THE AREA INCLUDED IN THE POINT REYES NATIONAL
> SEASHORE.

The legend then refers to the map shown in figure 1, which includes all of Tomales Bay, a total of 3,350 acres, to be within the park,

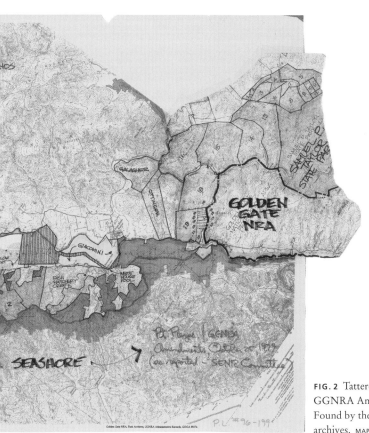

FIG. 2 Tattered map entitled "Pt. Reyes & GGNRA Amendments, October 25, 1979." Found by the author at the GGNRA archives. MAP COURTESY OF GGNRA ARCHIVES

except for a strip along the western edge that is part of the Point Reyes National Seashore (see page 77).

However, none of the NPS maps bore the magic title, "Point Reyes & GGNRA Amendments, October 25, 1979." They were merely internal Park Service maps, prepared after the legislation.

The archives staff seemed genuinely excited about my quest for the missing map, and they decided to dig a bit deeper than they had earlier. Suddenly, there appeared a mailing tube with four old, rolled maps, not fully catalogued and probably not viewed for many years, if not decades. We put on protective gloves and unrolled the crumbling maps on a large viewing table. I was reminded of the pirate maps I made as a child.

I thought we might be getting close, and we were. Bingo! There it was, with edges torn, a parchment-like, semi-transparent map, colored with Magic Markers (fig. 2).

In the bottom-right corner appears the correct title, handwritten in red: "Point Reyes & GGNRA Amendments, October 25, 1979." Beneath the legend is a reference to "P. L. #96-199," the 1980 law that expanded the GGNRA boundary to include the lands depicted on the map.

Detail of fig. 2

There was a loud cheer in the somber, library-like atmosphere of the archive building.

As word of the discovery got out, email congratulations came in from the officials who had been involved in the search. Colin Smith, Chief Park Ranger wrote, "I'd love a copy of the whole thing. Good work." Greg Gress of the regional office wrote, "Wow! Great job ferreting out this long lost map! We look forward to comparing it [with] our land status maps to see if we've correctly reflected the intent of the legislation."

But the thrill of discovery was soon tempered. On closer inspection, I saw that while the map's title was correct, it was a copy, not the original. At the top of the map was this legend:

Detail of fig. 2

"P. B." was Congressman Phil Burton. And "DN," the person who had drawn the copy on April 15, 1980, was Douglass Nadeau, the senior park planner who worked closely with Burton on park legislation. Why was the copy hand drawn? I realized that in 1980, large color copiers were not common.

Still, Nadeau's carefully drawn duplicate map, prepared only a few weeks after President Carter signed the boundary expansion law, seemed to be a true copy of the 1979 statutory map.

Most important, the map clearly answered the question, "Is Tomales Bay part of the park or not?" It is not. According to the map that Congress approved, the GGNRA boundary does not include Tomales Bay. Today's park maps are wrong.

MYSTERIES DEEPEN

Discrepancies between the statutory map and the maps drawn by the Park Service raised some very big questions. If the bay is not within GGNRA boundaries, why did the maps prepared by National Park staff a few months later specifically include Tomales Bay in the park? And why do all modern park maps show the bay within the park if Congress never approved it? Further, how can park rangers enforce park regulations in the bay if it is not within their jurisdiction?

To find answers, I decided to look into the history behind the 1980 boundary law: speeches made to Congress, committee hearings, and committee reports. I expected the research would help determine what the 1979 map was supposed to show and whether Tomales Bay itself was supposed to be included in the park.

Those were the days when Burton had enormous influence in Congress and often pushed through legislation that still needed to be fleshed out—something that would probably be impossible in today's digital world. Burton would often pack his bills with federal park designations in districts of key legislators to obtain their votes, a practice that became known in Congress as "park barreling."

When the GGNRA boundary expansion law was originally proposed to Congress in early 1979, it referred to a map, identified as 80,003-L, showing the new territory. The House of Representatives first passed that version of the boundary expansion bill in May 1979.

And what did map 80,003-L show? I was amazed to learn that no such map was created. Two months after the House voted to approve the map, a Senator asked the Park Service for a copy and received this response: "This map has not been completed. Our Regional Office in San Francisco is working on the intended boundary to be reflected by the map."

So, there was precedent for Congress to vote on Burton's park expansion without having the statutory map in hand—or even drawn! As the bill made its way through Congress, the reference to map 80,003-L was changed to refer to Nadeau's Magic Marker map, "Point Reyes & GGNRA Amendments, October 25, 1979."

As Nadeau explained, the ephemeral nature of these maps was a product of Burton's approach to legislation: "When [Burton] was cooking up a new boundary proposal, he would describe it verbally and ask me to draw a map. With limited time, I would respond with a quick-and-dirty Magic Marker un-reproducible original. Weeks later, legislation would appear referring to this mysterious map of unknown origin and location."

In February 1980, in a speech before the final Congressional vote on the matter, Burton provided the House of Representatives with an extended and detailed description of the new territories to be included within the GGNRA, lot by lot, with acreage estimates, including this statement: "All of the undeveloped lots, parcels, lands and interests in lands West of Hwy. 1 (to Tomales Bay)."

However, in none of the Congressional committee hearings, nor in any of the committee reports, nor in any of Burton's speeches in Congress was there any mention of including Tomales Bay itself in the park's expanded boundary. Nor did the acreage estimates in Burton's speech include the bay's 3,350 acres. Nor did the lengthy report in the *San Francisco Chronicle,* which detailed the new boundary after the vote, suggest that Tomales Bay itself would be included.

Both the legislative history and the 1979 map make it absolutely clear: Congress did not include Tomales Bay within the boundary of the GGNRA.

So the question remained: Why did the Park Service publish maps a few months later showing Tomales Bay within GGNRA boundaries—a practice that continues with the park maps of today?

HIJACKING TOMALES BAY

John Sansing, Superintendent of Point Reyes National Seashore when the bill was passed, had responsibility for managing the northern portions of the GGNRA. After President Carter signed the law in March 1980, it was Sansing's job to know what lands were within the park boundary. But, as he later wrote, this was without him or anyone who was drawing the official park maps having access to the 1979 map referred to in the legislation.

I asked Sansing, now long since retired, whether Tomales Bay was supposed to be included. "One day it was in, one day it was out," Sansing recalled. "We were confused." What confused him was what confused me. As he wrote in a memorandum nearly three years later, "We've not been able to find the legislative language which extends the boundary…to include the bay."

Burton, however, was not confused, nor did he feel obliged to follow the 1979 map or his own speeches to Congress. According to Nadeau's notes at the park archives, well after the law had been passed by Congress, Burton told Nadeau that the park's new boundary included "all State lands and submerged lands," presumably referring to Tomales Bay. It seems that Burton acted on his own to expand a national park boundary—an authority that is properly exercised through an Act of Congress.

With Burton's mandate, it would just be a matter of time before Nadeau got out his Magic Markers to draw yet another map,

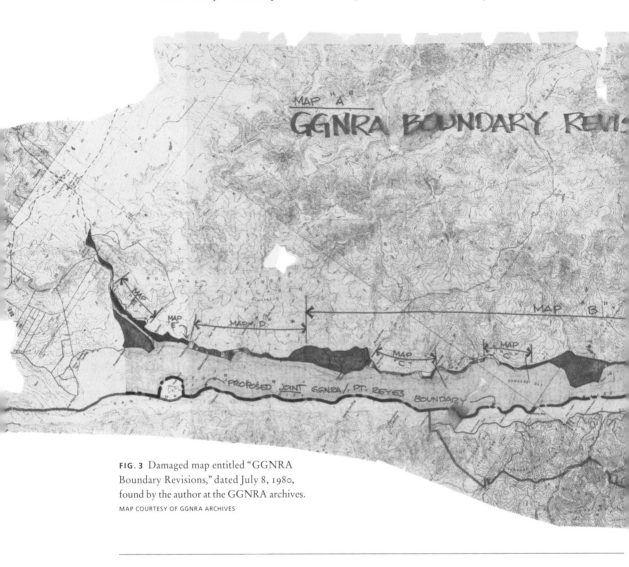

FIG. 3 Damaged map entitled "GGNRA Boundary Revisions," dated July 8, 1980, found by the author at the GGNRA archives.
MAP COURTESY OF GGNRA ARCHIVES

this time with the bay included within the park boundary. And sure enough, that map, dated July 8, 1980 and entitled "GGNRA Boundary Revisions," was also in the tube of old maps I found at the park archives (fig. 3). It was the most tattered and torn of all.

In contrast to the 1979 map that Congress had approved, Nadeau's July 1980 map is much more detailed; moreover, it accurately reflects what Burton said in his speech. It shows the GGNRA boundary to include the undeveloped properties along the east shore

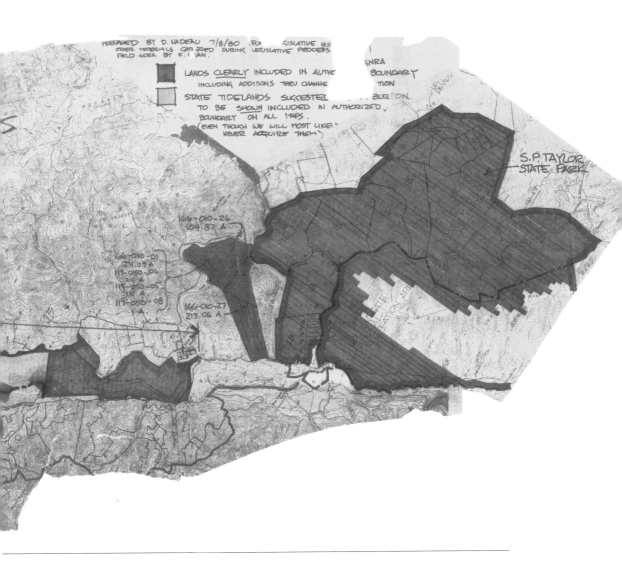

of Tomales Bay and to exclude the developed ones, creating a patch-work along the edge of Tomales Bay. Most revealing is Nadeau's legend at the deteriorating top edge of the map.

With the torn-out portions supplied, the legend would read:

Prepared by D. Nadeau 7/8/80 from legislative history and (?). Other materials gathered during legislative process Field work by F. Dean

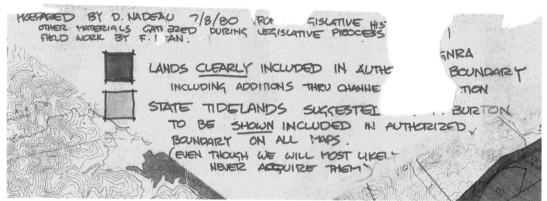

Detail of fig. 3

The legend, with words underlined by Nadeau, reads:

> GGNRA
>
> ■ Lands <u>clearly</u> included in authorized boundary including additions thru channel islands legislation
>
> ▨ State tidelands suggested by P. Burton to be <u>shown</u> included in authorized boundary on all maps (even though we will most likely never acquire them)

Finally, the answer! The "Lands *clearly* included in the authorized boundary," which Nadeau colored with a dark green Magic Marker, did not include Tomales Bay. Rather, he marked Tomales Bay in light green, representing "State tidelands suggested by P. Burton to be *shown* in authorized boundary on all maps"—even though no legislation had included Tomales Bay in the park boundaries. As Superintendent Sansing said of Burton's suggestion, "He was good at telling staff what to do."

When Burton told Nadeau to show Tomales Bay within the park boundary, it must have put Nadeau in a very difficult position. He would have known that Congress had not included the bay in the

legislation, but the very powerful Phil Burton made his instructions clear. Walking a delicate line between his responsibilities as a park official and the demands of Representative Burton, Nadeau drew a map that included the bay in the park boundary, but with a caveat of sorts—differing shades of green Magic Markers, noting that the bay itself was only "suggested by P. Burton to be *shown* included."

Perhaps inevitably, Nadeau's disclaimer literally became a faded footnote on a tattered scrap of history. A few months later the Park Service published its new maps. Following Burton's suggestion, the mapmakers showed Tomales Bay within park boundaries. Notably gone on these maps—and all subsequent maps up to this day—are both Nadeau's map legend and his color gradations clarifying what is law and what is suggestion.

Burton's suggestion is still being observed today, with park rangers patrolling the bay and issuing warnings and citations for violations of national park rules, despite the lack of Congressional authorization. If you want to confirm that, try hunting ducks in the middle of Tomales Bay.

POSTSCRIPT: THE MYSTERY OF THE TOWN OF MARSHALL

My question was answered, but the peculiar mention of the town of Marshall in the federal law remained unexplained until I discovered a piece of correspondence.

In his speech to Congress when the boundary law was passed, Burton said that he wanted to exclude from the park "the Town of Marshall, from the Post Office building on the north to the last undeveloped lot on the south of the Town." But shortly thereafter, Jerry Friedman, a long-time local environmentalist, sent Burton a letter with this comment: "Since the town of Marshall is really a long line of homes often separated by vacant parcels, right now we do not have a definitive idea as to which developed lot is the southernmost edge of the town."

To clarify the matter, Burton got Congress to pass clean-up legislation, adding this sentence: "For the purposes of this subchapter, the southern end of the town of Marshall shall be considered to be the Marshall Boat Works."

Amazingly, neither Burton nor Friedman nor anyone else noticed that Burton's stated intention to exclude Marshall was never actually written in the law! So the stand-alone definition of the southern end of the town of Marshall is a curiosity, but it is legally meaningless. It lives on as a relic of the fast-and-loose times of the Burton "park barreling" era.

Congress should now decide if Tomales Bay will be part of the GGNRA. Until then, park rangers cannot legally enforce park rules in most of the bay. I believe that a fitting tribute to Burton's legitimate accomplishments would be for Congress to add Tomales Bay to the national park—legalizing his suggestion that the Park Service has followed for thirty-two years.

As a final footnote, Congress should delete the dangling reference to the town of Marshall from the United States Code.

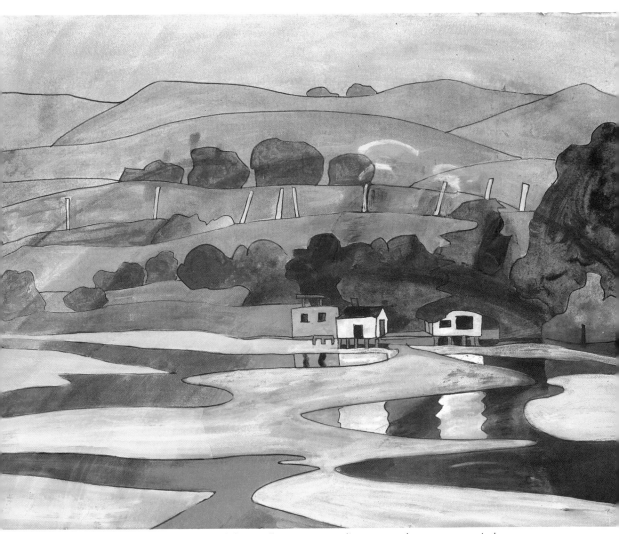

Shirley Salzman, *Looking North from Millerton*, 2011, acrylic on watercolor paper, 30 × 22 inches

Flight Plan
Gary Thorp

In years of drought, dragonflies enter the city,
 desperately
seeking ponds or lakes that are not there. They lay
 out lines of
their eggs on the hoods of automobiles, the shining
 roofs of
buses, or upon any other gleaming surfaces that
 might resemble
water. Firmly stuck to the enamel, steel or glass
 upon which they
were lain, the eggs perish. The thwarted dragon-
 flies then leave
for more hospitable surroundings.

Any personal data on these dragonflies is to be
 kept confidential
and secure and should not be sold, given away or
 used for any
commercial purpose. Data regarding the eggs
 appears to be in the
public domain and may be used at your discretion.
 Please do not
tamper with actual eggs found on any personal
 vehicles. Try to
show respect for our fellow beings of the air.

The sorrow of a dragonfly would be a difficult
 thing to assess,
whether one is flying or standing still. Insects are
 not known for
their outward displays of emotion. They do not
 wear their hearts
on their sleeves. They have no sleeves.

My own tactic is to remain still during times of
 drought. When the
weather is too hot, I often cease moving altogether.
 The glare of
motor vehicles and these acres of pooled sunlight
 keep me pinned
in a position as close to the ground as I can get. This
information should be considered as personal data
 and should not
be published, recited, reproduced or stored in any
 written form,
either mechanically or electronically. While sitting
 here
motionless, I have written these words for your
 eyes only,
surreptitiously, on one of my most beautiful wing-
 like sleeves.

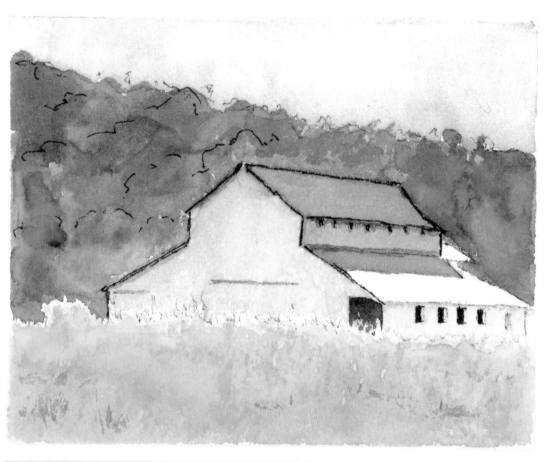

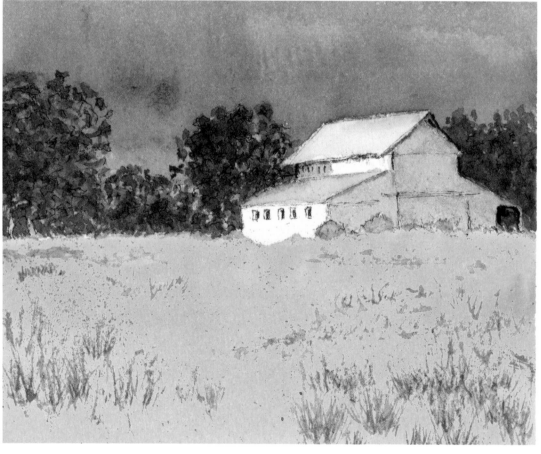

Kitchen Tables

Mark Dowie

WHEN I moved to California from Wyoming in 1963, at twenty-four years of age, the most recent item on my résumé was "cowhand." My last employer was the Double Spearhead Bar Ranch, a good-sized cow-calf operation about four hours north of Cody in Sunlight Basin. I was a Goldwater Republican and I had trouble spelling "environment."

One of the first books I read in California was *Silent Spring*. Rachel Carson introduced me to a world I had been living right next to, utterly blind to its molecular biology and unaware of the threat I had been to its vitality—mostly by overgrazing cattle and spraying hayfields with chemicals whose names I couldn't pronounce. Gradually, ever so gradually, I became a penitent though reluctant environmentalist—reluctant because I knew that Carson's message would not sit well with my hay-farming neighbors in Wyoming. Even a mention of her name, or, worse, the Sierra Club, which I had secretly joined, would convince them that I had fallen in with the devil.

In the years that followed, I became increasingly active in the environmental movement, mostly at the grassroots level, although in the mid-1970s I joined the board of Greenpeace, which soon thereafter became the largest environmental organization in the world.

Later, as a journalist, I wrote articles in national magazines about endangered species, toxic chemicals, and lost wilderness, articles that might prompt the few literate cowboys I'd ridden with to put a bullet through my head.

Christa Burgoyne, (top) *Pt. Reyes Barn #1*, 2011, watercolor, 4¼ × 3½ inches; (bottom) *Pt. Reyes Barn #2*, 2011, watercolor and pen, 4¼ × 3½ inches

When the inevitable backlash against Greens began to germinate in the West, I took a natural interest in the anti-environmentalists who called themselves "Sagebrush Rebels." They sounded like my people: folks who were tired of grazing their cattle on land the feds owned and were calling for the privatization of every acre west of the Mississippi. That didn't seem like such a bad idea—I thought family ranches with a personal interest in the land could do a much better job of conserving it—until I discovered that the people behind the rebellion had no interest in family ranches.

They were timber men, developers, oil 'n gas explorers, and miners in $200 Stetsons, exploiting cowboy mythology to win range romantics like Ronald Reagan to their cause. Of course Reagan fell for it. His first day in office he declared himself a Sagebrush Rebel and appointed their main lawyer, James Watt, to be his first and our nation's most embarrassing Secretary of the Interior.

The Sagebrush Rebellion later evolved into something called the "Wise-Use Movement." This development disturbed me even more than Watt's perfidy, not only because it seemed like an abuse of terminology, but because I knew that its road show would take some of the conniving Wise-Use charlatans who were circuit-riding the West past Heart Mountain, over Dead Indian Peak, and straight into Sunlight Basin, where I had worked. There, people I loved and respected would listen intently while the agents of extraction—miners, loggers, frackers—told them wild tales about environmentalists, bankers, and bureaucrats out to steal their land. And my old friends would believe it. Wise-Use advocates are good performers, and they have enough sense to make a personal call to present their case. Kitchens are their venue.

Sure enough, on a trip back to my part of Wyoming in 1993, I visited a few old friends and discovered that a host of conspiracy-scoundrels had been right where I was sitting, in my former neighbors' kitchens, telling them that "preservationists" in Washington were

conspiring with the federal government and the United Nations to expand Yellowstone Park into Sunlight Basin and reintroduce wolves to their pastures.

There was enough truth in their story that I began to sympathize. Wolves were being introduced into Yellowstone (though not into Sunlight Basin) and we all knew about stuffed shirts in Washington. Three days into the visit I realized that had I stayed there in Sunlight Basin, I would now be a committed warrior in a movement whose concept of land stewardship was exploitive, rather than wise or useful.

Three years later, I spent time in New Mexico covering the so-called "county movement," a Wise-Use initiative that began in Catron County and was attempting to claim county sovereignty over federal land nationwide. The week before I arrived, a Wise-Use promoter named Chuck Cushman had been through, inciting the citizens with conspiracy theories, most of which intensified the anti-Semitic rants of Aryan evangelists who'd been by a few days before him.

In Reserve, Catron's county seat, I watched a Christian Identity preacher named Reverend Pete Peters seduce a gaggle of TV cameras to the town square, where he persuaded local citizens to spit on the UN flag before he torched it. There was much talk in the square of unmarked helicopters and an impending federal invasion—a firearms raid most folks believed was imminent. "Ruby Ridge and Waco are also on our minds," a cabinetmaker told me.

My reporting took me to the home of a rancher and county commissioner named Hugh McKeen. McKeen had voted for resolutions to pass control of all public land in Catron County directly from federal to county government and to give the local sheriff power to arrest Forest Service and Bureau of Land Management officers—two bodacious resolutions that passed unanimously and seemed sure to land McKeen and his lawyers before the Supreme Court.

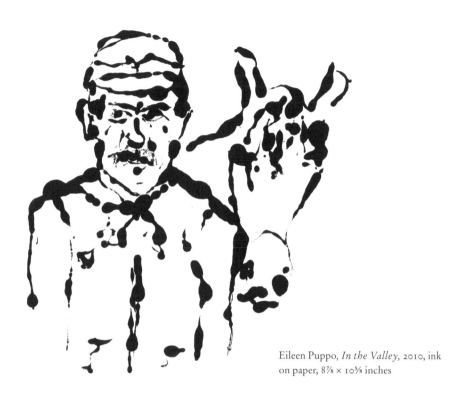

Eileen Puppo, *In the Valley*, 2010, ink on paper, 8⅞ × 10⅝ inches

I had been forewarned that this was one mean son of a bitch who would "shoot an environmental extremist on sight" and would kick me out his back door if he knew I was writing for *Outside* magazine. My advisors, environmental activists living in the country south of Catron, were off by a country mile.

I told McKeen first thing whom I was working for. "Come in," he said, "coffee's hot." We sat in his kitchen for most of the morning, talking about the life he had chosen, and the one I had left. In the course of our conversation, he told me how he loved hiking with his kids in the Mogollon Mountains, floating the Gila River, and reading Aldo Leopold (who had lived not far from his ranch). "You sound like an environmentalist, Hugh," I said.

He paused for a moment, looked straight at me without smiling, and said, "Nope, couldn't be."

"Why not?"

"Because environmentalists hate cows."

Could it really be that simple, I wondered? Are we that close? Was McKeen's passion for open space, white water, and Leopold's land ethic separated from my environmental colleagues' love of the very same things by a differing view on cattle?

I asked McKeen if an environmentalist had ever been in his kitchen. "Never," he said, "but they're welcome if they care to talk sense about cows." New Mexico Greens' slogan for public land had been "Cattle free by '93." McKeen was unlikely to get satisfaction from them.

When I told him I would send him a copy of *Outside* when they published my article, he handed me six back issues of *Range Magazine*: "I'll read *Outside* if you read these." I did, and read more when I went back up to Wyoming the following spring to help with branding. Everyone there subscribes to it.

I now recommend *Range* to every environmentalist I meet who's working on land issues, not because I agree with everything the magazine says, I don't, but because it documents the fact that most ranchers and farmers in the West care as much for the health of their land, air, and water as any member of the Sierra Club.

They both value healthy ecosystems and quiet open spaces, and lament the decline of neotropical songbirds. And they both understand that the West as they know it is today threatened with an invasion of settlers who know nothing about land stewardship, care less about the future of family farms, and wouldn't recognize the song of a Wilson's warbler if it were sitting on their shoulder.

In one issue of *Range* I found a profile of a guy named Dan Dagget, a wolf-loving, former Earth First! monkey-wrencher, who at the behest of some moderate wolf advocates, sat down with half a

dozen arch-conservative Arizona ranchers to seek a way to reintroduce wolves to the range. In the course of exploring that challenge and discussing land restoration methods with those landowners, Dagget experienced an epiphany.

Land, he came to realize, could actually be protected, in fact revitalized, with proper livestock grazing. He eventually wrote a book about it: *Beyond the Rangeland Conflict: Toward a West That Works.* It relates the stories of ten ranchers who tried and made a success out of rotational grazing. At least once a month, I recommend that book to skeptical Greens, so many of whom still believe that cattle can only be bad for pasture land.

Well, I'm back where I belong, surrounded by farms and ranches. I tried city life once or twice, but never felt comfortable too far from agriculture. A few times a year I go on cattle roundups, both here in West Marin and in Montana where my son and his mother moved their ranch and cattle from Wyoming. I help them and my neighbors with branding, preg-checks, and inoculations. I do it to keep a hand in the work I have always loved best—"cowhand." It's still on my résumé.

I remain an environmentalist. I believe we all are at heart. But I'm a hybrid, a fence-sitter, observed with caution by ranchers and Greens alike. I've lost a few friends on both sides of that fence.

The science of land stewardship is still unfolding and it's hard to know what's right. But it seems clear that one right thing is communication. Close, patient, and honest dialogue between ranchers and enviros will make great strides toward right-stewardship and toward consensus in the land disputes that plague the West. Those conversations are often best had around kitchen tables.

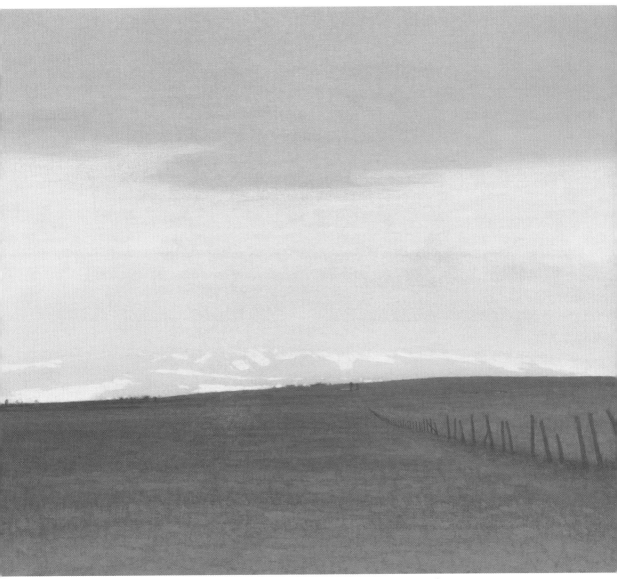

Russell Chatham, *Looking Toward the Absarokas*, 2008, oil on canvas, 36 × 30 inches

Selection from *One Stroke One Breath*

A WORK OF POETRY & CALLIGRAPHY IN PROGRESS

Claudia Chapline

first day of the year
foam and feathers flying
I hold my hat

Inverness Summer

Jacoba Charles

Inverness summer:
Fog in the morning, chainsaws
every afternoon.

Sabine (Bree) Terrell, Grade 12, *The Birds'*
Song, 2010, collage, 11 × 14 inches

Dystopia

Margaret Chula

What if, in one hundred years,
to be or not to be was the only question

its attribution long forgotten — words like *sonnet*
and *behold* lost in the backwater of memory

peacemakers of the last century
reduced to a tatter of sari behind glass

a prayer wheel, a typewritten speech
moldering in a vault beneath a dead city

below the sewers that clog the legacy of dictators —
puppets with pockmarked faces and moveable arms

their eyes dark bullets, noses chiseled into pyramids,
smiles extinct as grasshoppers?

Falling in love would be forbidden —
passion bred out of the human race

programmed to reproduce upon demand.
Each tree would have a name branded on its bark:

pine/maple/hemlock. Ownership would be
the benchmark of success, and the have-nots

spewing emotion, will rank lower than robots.
What will it matter if clouds are no longer white

if rivers run like gun-metal clogs, if nightingales
have lost their blood-red tongues?

Austin Granger, *Tomales Bay*, 2002, photograph

The Language of Baskets

Carola DeRooy

MORE THAN two hundred years ago, members of various foreign expeditions collected Coast Miwok baskets and feather regalia in what is now Marin County. At that time, baskets of all types were integral to California Indian life, made for various stages of food gathering, production, storage, and cooking and incorporated into ceremonies, games, medicine, and gifts of status. Basket weaving was essential in creating useful objects and uniting a community. The uniquely identifiable patterns, materials, construction, and skilled craftsmanship we observe in Native California baskets rival those of the most advanced basket makers around the world—then and now.

Coast Miwok baskets are extremely rare today. Tribal generations pass them down to family, and precious few exist in this country's museums compared with a prolific number of examples from many other tribal groups. Some of the finest examples of Coast Miwok baskets reside in museums in Russia, Germany, Switzerland, and Spain. These countries sent early naval and overland expeditions to California,

including naturalists, astronomers, scientists, and artists from Europe who recorded and collected cultural objects and natural specimens. The expeditions disrupted the traditional life of the coastal people forever, bringing previously unknown diseases and ushering in the colonial period. But the acquisition and preservation of traditionally made pieces was farsighted. Today they help us understand and appreciate the native people who have inhabited this area for thousands of years and whose skillful use of natural materials transformed those materials into objects of great beauty and significance.

DESCRIPTION
Coiled basket, tight start coil, three-rod willow foundation warp; left worked, exterior workface

Plain wrapped rim, overstitched diagonally

Weft fag ends appear to be bound and concealed under the workface

Moving ends are on the backface (inside)

Light tan sedge root with darker geometric pattern woven in with bulrush or bracken fern

Clam shell beads stitched on the rim with twine

Olivella shells stitched into the workface

Strings of olivella shells ending with abalone pendants attached with twine on basket face

Twine string attached for hanging basket

Two colors (characteristic of Northern/Central California)

REPOSITORY
Ethnographic Museum of the University of Zurich

CATALOG NUMBER
00466

MAKER
Coast Miwok (Marin and Southern Sonoma County, California, USA)

COLLECTOR
Johann Casper Horner (1734–1834), Swiss physicist and astronomer on the vessel *Nadeshda*

DATE COLLECTED
1803–1805 on the Kruzenshtern Expedition, the first Russian world circumnavigation

BASKET TYPE
Presentation Basket: virtuoso basket made for wedding, honoring someone, gift

MATERIALS
Warp rod foundation: willow (*salix lasiandra*)

Weft (lighter color): sedge root (*carex mendocineosis*)

Weft (dark pattern): bulrush (*typha agustifolia*) or bracken fern (*pteridium aquilinum*)

Twine: possibly milkweed (*asclepias syriaca*)

Photograph courtesy of Ethnographic Museum of the University of Zurich

Toni Littlejohn, *The Lioness*, 2009, acrylics and collage on paper, mounted on board, 65 × 28 inches

Quail Fog

Donald Bacon

Fog webs the eucalyptus tree—
 torso of trunk,
 elbow branch

apparitions
slipping into strands and swirling traceries,
sprays of tumbling mist
streaming from the domed, monolithic wall of fog
rolling up the pasture
from a fogbank off Point Reyes Light—
 O disembodied netherworld,

drifting in a shroud of blank ghosting whiteout
and silence,
a cloud of implacable shivering silence,
 descending everywhere.

Beneath the cavernous, draped and sliding floor
a crevice opens,
luminous canopied chamber—
 nimbus, mirage
 phantom quail foaming in mist

No, a solitary male
scrabbling seeds from a stubble of foxtail,
nodding a black plume,
strutting gossamer quicksilver spots on his breast.

He freezes. And then—

 onset, frenzy
 jolting the silence, startling the fog

An invisible covey
cracks in a flush of booming wingbeats,
whirring soar, clattering slam through the roof—
 arc of sight
 diaphanous wedge of flashing feathers—
dips, disappears, foreclosed and congealed again
in the numinous silence.

 Mysterium fascinosum. Mystical moment.
 An ordinary morning on Tomales Bay.

Francesca Preston, *Irises and Paper,* 2009, photograph

Many-Roofed Building in Moonlight

Jane Hirshfield

I found myself
suddenly voluminous,
three-dimensioned,
a many-roofed building in moonlight.

Thought traversed
me as simply as moths might.
Feelings traversed me as fish.

I heard myself thinking,
It isn't the piano, it isn't the ears.

Then heard, too soon, the ordinary furnace,
the usual footsteps above me.

Washed my face again with hot water,
as I did when I was a child.

Rutilio Plasencia, Grade 12, *Arbol de la obscuridad,*
2010, watercolor on paper, 9½ × 13 inches

Igor Sazevich, *Olema*, 2011, oil on canvas, 36 × 36 inches

Etiquette

William Masters

I RIDE elevators.

To reach my office in downtown San Francisco I first take the escalator from the ground floor to the mezzanine. From the mezzanine I ride an elevator from elevator bank A to the twenty-first floor. From the twenty-first floor I switch to elevator bank B and ride to the thirty-third floor, on which my office is located. If I arrive in the building between 8:30 and 9:00 AM, multiple stops at various floors extend my ride by six to ten minutes.

I rely on gearless traction electrical thrust to deliver me to work.

In order to arrive on time I must add elevator travel time to my bus commute. Eighteen minutes plus twelve minutes equals thirty minutes. Of course, I must add an additional six- to ten-minute wait for the bus, which, theoretically, follows its 2007 schedule, but in reality (with a couple of early morning exceptions), runs on its own maverick schedule based on breakdowns, weather conditions, and driver disposition.

In 1857 my great-grandfather rode in New York City's first elevator, an Elisha Graves Otis design, a steam-powered car moved by a system that used a belt-driven winding drum. When great-grandfather arrived back home in Rochester, he was met by the editor and photographer of the *Rochester Gazette,* who took his picture and asked him if he thought he would go to hell for riding in a hoisting device that offended God.

"Only birds and angels have the right to move that high," the editor proclaimed.

My great-grandfather politely replied that angels had a great deal farther to go than five floors. "Elevators will not become a path to reach heaven," great-grandfather said authoritatively.

The next day, after his picture and short interview were published, he became a local celebrity, though shunned by the more pious members of the religious community, until 1873, when a Presbyterian minister from Rochester attended a religious convention in New York City at the Gabriel Arms hotel, in which he rode the elevator to his room on the ninth floor.

In my grandparents' day, every elevator had an operator, usually in uniform and often seated on a polished wooden stool, to run the technological marvel. Men took off their hats inside elevators, while most women still wore hats and gloves. No one ever considered eating or drinking between floors. At each stop the operator called out the floor number. Men would automatically step aside to allow the women to exit first.

In my parents' day, some elevators still had operators who may or may not have worn uniforms. A passenger's disapproving glance or lifted eyebrow might embarrass a man into removing a hat or prevent him from unwrapping a candy bar. Women still followed the nod of a man's head or the hand gesture signaling permission to enter or exit the elevator.

Today, almost all elevators, save the elegant hotel car located in a major city or the express run in a corporate headquarters, operate as self-service transportation. Still, such elevators often boast richly polished wooden panels, occasionally carved up by a bike messenger, or marble inlays adorning polished stainless steel interiors, infrequently marred by the grease pencil of someone wandering around in the building who managed to evade security.

Fashion conspires with bad taste to encourage hat wearing in elevators, while vanity encourages the application of fragrances in amounts far exceeding any limits of propriety, or in some instances, of safety. I have witnessed a fellow passenger overcome by another rider's perfume in such a tight space.

Tact and consideration to fellow passengers have diminished to a whisper. Completely oblivious to my presence, I overheard one employee pitch to her boss the termination of another employee whose work, she said, was consistently careless, causing grief to other employees.

"Have you documented the mistakes?" asked the boss. The other employee shook her head. "Then you can't terminate her. But if you have the corroboration of other employees you can put her on probation. Ninety-six percent of employees on a second probation perform below acceptable standards. Then you can terminate her."

"She's African American," the woman added. The boss shot her a hostile look.

"Then you'll have to give her some retraining or switch her around to another job and hope it works. With another wrongful termination suit in this company, I'll be gone."

On the following morning, I had an 8:00 AM emergency dental appointment located in the 491 Post Street medical building. Although my dentist's office was on the thirteenth floor, I hit the fourteenth floor button, since most buildings do not use a number thirteen and skip from twelve to fourteen on the numbered floors. These days such methodology follows fashion rather than superstition.

Just before reaching the eleventh floor, the elevator stopped, the lights went out, then came back on at a lower wattage. An alarm rang three times, and a woman's voice from a speaker on the left panel of the elevator spoke: "Hello, can you hear me?"

I replied that I could.

"My name is Rita. Are you OK? Please tell me your name."

"Glen Hanson," I replied. I complained that I had a toothache and asked her to contact my dentist, Dr. John Noren, and tell him I was stuck in the elevator and would not arrive on time. I laughed out loud.

"We're working on the problem, Mr. Hanson. Please open the panel on the left side of the elevator door and check to make sure a flashlight is there and that it works." I followed the instructions and replied that it was and it did.

"We've called our elevator person to diagnose and repair whatever the problem is. Can you breathe alright? Is there enough air in the car?"

Before I could respond, I heard the hiss of oxygen flowing from somewhere in the right panel. "I am in pain," I said, annoyed. "Pain from a toothache. But I can breathe fine. Where is the elevator repair person coming from?" I asked, trying to estimate how long I might remain stuck.

"He's already on his way from Vallejo."

"What! From Vallejo?" Vallejo is a forty-five-minute drive from San Francisco, not to mention the wait time at the Bay Bridge.

"We can alert the fire department," a deep voice without the courtesy to introduce itself responded.

"You do that. And also alert the Bay Area Regional Elevator Company, which is the brand and installer of this elevator. I am reading this information from that panel on the left side of the elevator: *We are proud that you are riding in a Regional Elevator Company product.* They're *proud!* And may I ask, where is Rita?"

There followed about a minute and a half of silence. Ninety seconds stranded alone in an elevator eleven stories up in a downtown building in San Francisco with the emergency repair person *on*

Mary Curtis Ratcliff;
Waterweb, 2008, Xerox
transfer, colored pencil,
watercolor, digital inkjet
print; 29 × 40 inches

his way is a lot longer than waiting ninety seconds in line at a
Starbucks or Peet's coffee house.

Rita returned. "I'm here, Mr. Hanson."

"Don't let them shuffle you away, Rita." I had decided to
elevate Rita to friendship status.

Suddenly, a new voice: "Hello, Mr. Hanson, I'm Jack Stock.
I'm the emergency fire department elevator response person. I just
spoke with the elevator people and they're on their way with a police
escort. All I can really do is to give you first aid, if you need it."

I tried to stop looking at my watch. I pictured a police car with siren on, clearing the way for the elevator company's emergency response vehicle. I was sitting on the elevator floor and imagined the ERV colliding with a California Street cable car. I sneezed. The continual rush of fresh, cool air into the elevator cabin had reduced the temperature. Although I still felt beads of perspiration dripping down my forehead, I also felt chilly. Or maybe I was going into shock.

Nonsense. Suddenly I remembered my toothache. "I'm in pain," I complained. "Remember, I'm here because I have a toothache."

"This is Ed Forester from the elevator company, Mr. Hanson. We're checking the mechanism right now. Trust me, we'll have you out of there very soon. Just give us a few more minutes to find a solution."

"I'm still here," said Rita. "We've called in a psychologist to speak with you as soon as we get you out and the fire department person confirms you don't need medical attention."

"But I do need medical attention. I have a toothache and I'm still in pain," I lied. My toothache had temporarily stopped. Probably abscessing now.

"This is Ed again, Mr. Hanson. Sit down on the floor."

"I'm already on the floor."

"Good. You'll feel the elevator make three short drops on its way to the tenth floor. At the tenth floor the doors will automatically open. Don't try to get up. Stay on the floor, and we'll remove you ourselves."

The elevator moved down and abruptly stopped, then repeated the move twice. The door to the tenth floor opened and Ed and Jack lifted me off the floor and sat me in a waiting wheelchair.

An elderly, grey-haired women appeared. "Rita?" I asked.

Then I requested the use of a bathroom, skipped the psychologist interview session, and rode another elevator to my dentist's office.

Later I learned that the elevator had an old, leaky, single-bottom jack that went directly into the ground. In-ground cylinders are prone to corrosion and electrolysis, which can lead to small leaks or catastrophic failure of the entire hydraulic system. The elevator at 491 Post Street did not have the update in the elevator safety code requiring that replacement cylinders have double bottoms, which minimizes serious safety and environmental risks. The building would receive a citation, pay a large fine and, of course, replace the old with a new system.

I called the *San Francisco Span*, the best of the three daily newspapers, and alerted it to what had happened. Their story ran the following day. Entitled "Elevator Scare in Downtown Medical Building," it asked, "How safe are you riding in an elevator? Do you defy the odds each day when you step into an elevator car that may have skipped its mandatory scheduled testing and still be running on old parts? Do you have enough life insurance to protect your family should the elevator fail and plunge to the bottom of the building, resulting in your premature death and necessitating a closed coffin at your funeral?"

Local radio stations and TV networks picked up the story, as did the UP, and it was reprinted in Los Angeles, San Diego, Chicago, New York, Atlanta, and Philadelphia newspapers.

Building managements all over the country began to recheck their elevator maintenance protocols and confirm that all mandatory testing had been conducted on building elevators.

Finally, the subject and story faded away, but it was not forgotten. The results of the article were always referred to as "the Hanson Effect," and for a few weeks I was a hero in my own city, but alas, every hero eventually becomes a bore.

"Call Dynah"

Introduction & Music Arrangement by Bart Hopkin

———

"CALL DYNAH" is a folk song from the island of Jamaica, harking back to an older and more innocent time. It's in the fine old tradition of complaining songs, with a bad back, a long and tiresome walk, and an uncooperative companion figuring prominently.

The song is arranged here for guitar and voice. It will sit nicely with soprano or tenor voice, but it could also be sung by an alto an octave below as it is written here. Alternatively, the voice part can be played on a flute or another melody instrument. In place of guitar, a pianist who doesn't mind reading entirely in the treble clef could play the accompaniment. In that case, remember that guitar music sounds an octave below the notated pitches.

The lyrics are in Jamaican dialect, which is different enough from American English that a translation may be helpful. The verses are rendered here by Janet Hopkin, a native of the island.

Bart Hopkin

Call Dynah

Here I am calling and calling Dynah;
Dynah hears me but she doesn't speak.
With this pain in my back I can't hurry,
Dynah hears but she's not answering,
I've got five more miles to walk.

I asked Dynah to buy a quatty¹ worth of sugar,
One big gill² of coconut oil,
Half-penny worth of pickled fish for good measure.
Dynah hears but she's not answering;
I can't hurry because of my back pain;
I've got five more miles to walk.

I asked Dynah to lend me her hat
Because the sun is burning the top of my head.
With this pain in my back I can't hurry,
Dynah hears but she's not answering,
I've got five more miles to walk.

1 *Quatty:* a coin, now long out of use, worth a penny and a half.
2 *Big gill:* a unit of liquid measure, no longer in use.

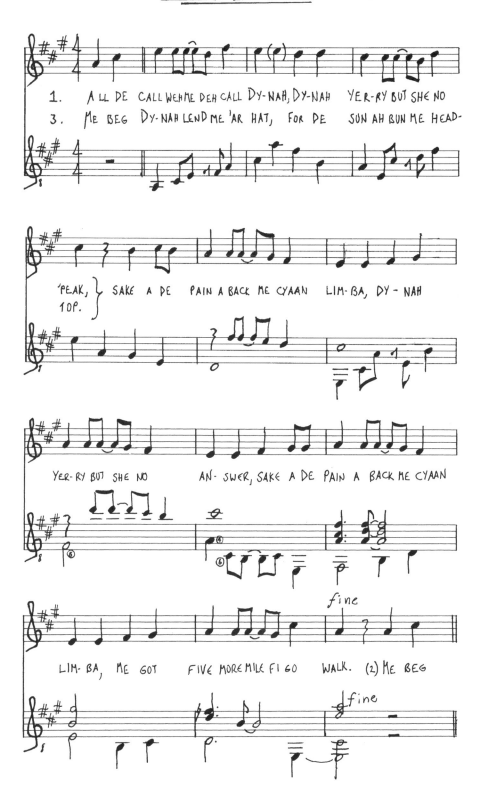

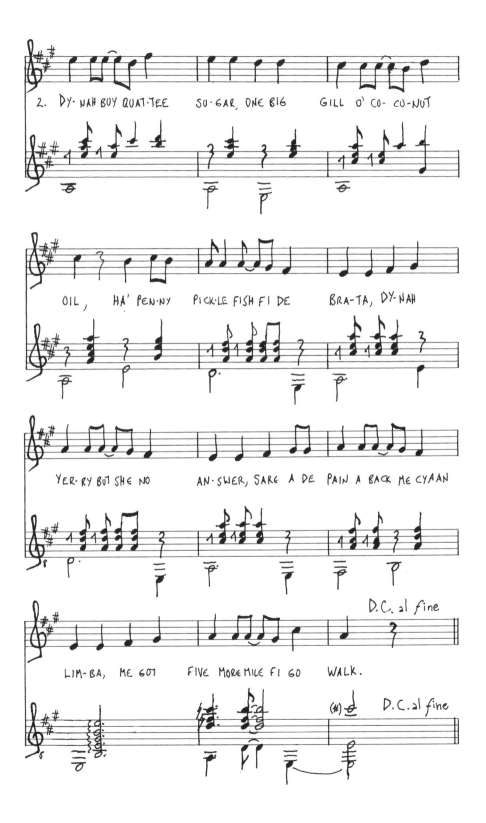

Fact

FOR JEROD

A. Van Gorden

Fact:

The songbird does not sing to give us pleasure.
Or so says our son's encyclopedia.
A young boy likes his facts, but we know better.
We have not come this far by playing beggar.

Glances, gold, and God are ours by thieving.
We sought each piece of bait we swallowed whole.
And it's unbearable to think, let alone remember,
The songbird does not sing to give us pleasure.

The city's loins lay waste to what we've counted,
So then we count their suffering as ours.
Love brings vigor to our every measure,
And we love the bird that sings to give us pleasure.

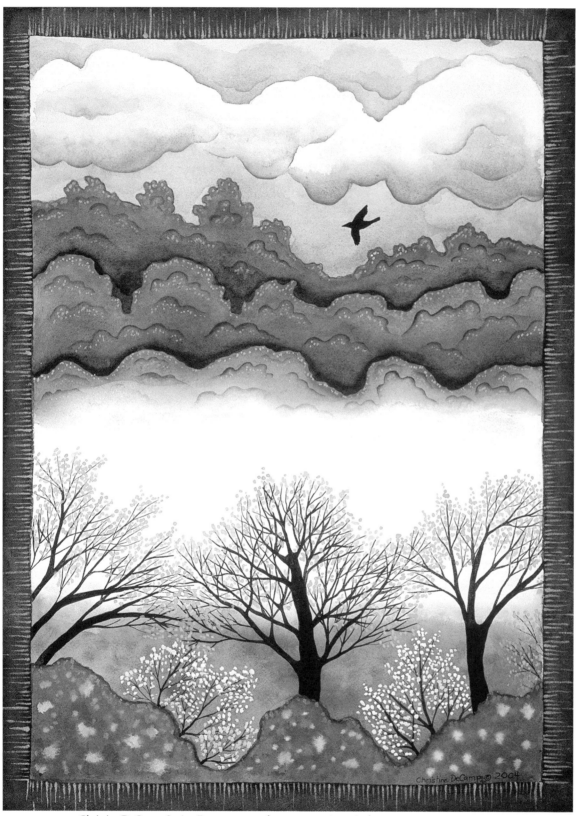

Christine DeCamp, *Spring Fog*, 2004, gouache on paper, 16 × 20 inches

Writers and Artists

JONATHAN AGUILAR is in his junior year at Tomales High School. He enjoys drawing and listening to music. He works at Pacheco Ranch in Chileno Valley and looks forward to moving to a big city once he graduates from college.

CALVIN AHLGREN, Tennessee-born, came West for graduate school and found his poetic voice in Northern California.

LESLIE K. ALLEN is a Mill Valley artist and architect whose paintings evoke the sensory experience of being immersed in the ecology of that specific place.

DONALD BACON retired from teaching English and American literature at Harvard and Stanford. The poem "Quail Fog" represents a direct personal experience at his family ranch above Tomales Bay in West Marin.

NANCY BINZEN is a shamanic practitioner who uses a variety of healing practices in her work, including drumming, journeying, and sound. She lives with her husband in Woodacre, California.

CHRISTA BURGOYNE is an artist who works in Berkeley and plays in West Marin.

EMILY CARDWELL lives in Inverness. She is nice, impatient, smart, not afraid to say something, good at singing, sort of responsible, nice with little kids, and good at acting.

CLAUDIA CHAPLINE is a left-handed artist and writer in Stinson Beach, where she owns an art gallery. She publishes books, poems, and articles on the arts in California.

JACOBA CHARLES is a science writer and occasional poet who grew up in the woods of northern Sonoma County, California and has lived for several years in Inverness.

RUSSELL CHATHAM has been painting since 1948. To a museum that declined to exhibit his work because "He isn't a contemporary artist," Chatham replied, "But I can show you my birth certificate."

MARGARET CHULA has published six collections of poetry. She is president of the Tanka Society of America and Poet Laureate of Friends of Chamber Music in Portland, Oregon.

GINA CLOUD lives in southwest Sonoma County, where she writes, teaches, gardens, and explores the hills and waters of Northern California. Her book of poems, *Night Apples*, was published in 2009.

GEORGE CLYDE of Marshall is a retired lawyer and sometime journalist who received an "Investigative Reporters and Editors Award for Outstanding Investigative Reporting" in 1992. He hosts the *West Marin Report* for local radio station KWMR.

CHRISTINE DeCAMP has been living and working in West Marin for twenty years. Her colorful paintings, inspired by the local landscape, often depict women in nature.

CAROLA DeROOY, archivist for Point Reyes National Seashore, enjoys shining a light on hidden layers of West Marin history to examine its relevance today. She is co-author of *Point Reyes Peninsula*, a photographic history of the area.

MARK DOWIE, investigative reporter and erstwhile radio host, lives at Willow Point on the western shore of Tomales Bay with his artist wife Wendy Schwartz, and Gracie, a canine-javelina hybrid.

ALVIN DUSKIN lives in Tomales, where he and his wife, Sara, host the writing group founded by Blair Fuller. He has six adult children and is CEO of Direct Carbon.

PAM FABRY, a Bolinas resident for twenty-six years, has been hiking the Point Reyes peninsula since the park was founded. She has worked as an architectural designer, photographer, writer, and graphic designer. She especially enjoys making art without a client to please.

JODY FARRELL has eighty-seven years of life experience to inspire her writing. After raising seven children, she now lives in Inverness Park with two cats and a dog.

OLIVIA FISHER-SMITH is an eighth grader at West Marin School who loves to sail on Tomales Bay and to surf locally. Her painting, "Submerged," was an art project in a class with teacher Laurie Sawyer.

KAYA GATELY is a seventh grade student at West Marin Elementary. She enjoys her art classes and wants to be an animator when she grows up.

AUSTIN GRANGER has been lugging his view camera around the American West for a decade. Though he now lives in Portland, Oregon, his favorite place in the world is still Point Reyes.

LISANDRO GUTIERREZ has lived in Point Reyes Station for fourteen years. He likes the beautiful views of the mountains. He also enjoys many sports, such as basketball and soccer.

SUSAN HALL grew up in West Marin and returned to paint Point Reyes after living in New York City for twenty years. Her work has been exhibited internationally.

ROBERT HASS teaches English at the University of California at Berkeley. He was Poet Laureate of the United States for two years, 1995–1997. His most recent book is *What Light Can Do*, a collection of essays.

JANE HIRSHFIELD's seventh book of poetry is *Come, Thief*. Her work appears in *The New Yorker, The Atlantic, Poetry, Orion, McSweeney's,* and seven editions of *The Best American Poetry*. Hirshfield was elected a Chancellor of the Academy of American Poets in 2012.

BART HOPKIN, a long-time resident of West Marin, lived and worked for several years in Kingston, Jamaica.

THOMAS JOSEPH attended elementary school in Fukuoka, Japan, lived in San Francisco for sixteen years, and currently works out of studios in Illinois and New Brunswick, Canada.

SALIHAH KIRBY has never felt more at home than in Point Reyes. She and her husband have been putting music and art to a Scandinavian sun cycle mythology called "Sun Ships."

JAN LANGDON lives in Point Reyes and has been weaving and teaching fiber arts in the Bay Area for more than thirty years. Tapestry is among the many fiber techniques that continue to interest and inspire her.

JON LANGDON is California born and raised. He received a BA from U.C. Berkeley, is divorced and a retired building contractor, and lives in Point Reyes Station writing poetry and painting. He is mostly happy and content.

FRANCES LEFKOWITZ is a magazine writer, book reviewer, and the author of *To Have Not: A Memoir*. She teaches writing workshops to children and adults in libraries, schools, bookstores, and retreat centers.

TONI LITTLEJOHN is a mixed-media artist living in Point Reyes. She is a founding member of Gallery Route One in Point Reyes Station and leads art workshops called Wild Carrots. She paints from her interior world.

CANDACE LOHEED is a member of Gallery Route One in Point Reyes Station. She has a studio/gallery/gift shop called orangeland in San Francisco.

HECTOR MARTINEZ is in his senior year at Tomales High. He likes to read, mostly fantasy and poetry, and to listen to Beethoven and heavy metal. A possible goal is to become a librarian.

WILLIAM MASTERS is a litigation paralegal. His story, "Etiquette," is from his unpublished anthology of stories, *Portraiture*, about life in San Francisco.

CAROLYN MEANS is a potter in Point Reyes who is fascinated by the process in which clay is transformed by fire.

MONTE MERRICK is a wildlife rehabilitator and a co-founder of bird ally x, an organization formed to help wild birds and the people who care for them.

CYNTHIA PANTOJA lives in Tomales, where she cares for animals, including her sheep and calves. At Tomales High she is president of the Future Farmers of America chapter and an advanced art student.

MICHAEL PARMELEY is a West Marin writer, lost in the hills, watching the world go by. Many years ago he was an infantry officer in Vietnam.

RUTILIO PLASENCIA was born in Balle de Guadalupe, Jalisco, Mexico. He is a senior at Tomales High working on a series of paintings that include images of trees combined with poetry. He plans to study mechanical engineering.

FRANCESCA PRESTON stitches wounds, unravels clichés, and brings language back from the dead. She answers to the name *grafista* and currently writes from the sandy outskirts of Petaluma, California.

SUSAN PRESTON has an MFA in painting from Mills College. For thirty-seven years she and her husband have been building Preston of Dry Creek, an organic farm and winery.

EILEEN PUPPO is an artist, poet, actor, radio programmer, and coordinator of West Marin Literacy, a program providing adults and families with student-centered instruction in reading, writing, and speaking English. She lives in Forest Knolls, California.

MARY CURTIS RATCLIFF lives in Berkeley and went to the Rhode Island School of Design. Her mixed media works on paper use the techniques of photography, transfer, paint, colored pencil, and collage.

SHIRLEY SALZMAN's landscapes grow out of a love of Point Reyes. She studied art at Berkeley in the 1960s and has been painting her heart out ever since.

IGOR SAZEVICH follows his desire to delve into landscapes of the mind by aspiring to encounter the realm of mirages shaped by colors and forms.

Christa Burgoyne, *Raven, Body Feather,* 2011, graphite pencil, 2 × 2 inches

F. J. SEIDNER, a retired diplomat, has lived in Inverness since 1992.

KATHLEEN ROSE SMITH of the Coast Miwok and Dry Creek Pomo tribes keeps traditional native California foods alive in workshops and books. Her paintings, in many styles, depict native California life.

MARNIE SPENCER is a painter living in Bolinas. Her piece, "Gullible's Travels," is a swiftly moving scrabble focused on a world invested [sic] with Rodentia (credit: Audubon) and Insecta and ripe with recreant potential.

GLEN STEPHENS is a retired attorney who divides his time between Southern California and Orcas Island, north of Seattle, Washington. His work has appeared in *Shark Reef, The Huffington Post,* and *The New Verse News.*

SABINE (BREE) TERRELL is a high school senior who moved to Scottsdale, Arizona from West Marin earlier this year. Her art is often inspired by her dreams.

PATRICIA THOMAS's drawings explore oppositions and connections in our social, historical, and interpersonal realities. She lives in Point Reyes and is represented by Slate Contemporary, Oakland and the SFMOMA Artists Gallery.

JOAN THORNTON, painter, writer, and long-time West Mariner, constructs artist's books, and contributes to projects at Sometimes Books and Gallery Route One, both in Point Reyes. She is a member of KNJ's poetry group, where she has discovered the fun in public reading.

GARY THORP has written essays, reviews, and two books of nonfiction. He is also a long-time haiku poet who has recently begun writing in more extended forms.

AMANDA TOMLIN likes to play with odd films, shutterless lenses, and large-format cameras, a combination intended to invite serendipity. She seeks unexpected shadows and shapes within the mundane and commonplace.

SUSAN TROTT has published sixteen novels and many short stories, having devoted her life to the art of fiction. She also plays ping pong.

ADRIENNE VAN GORDEN is a mother of two young children, and a teacher of English to middle schoolers. She lives in Palo Alto, California with her family.

HELEN WICKES lives in Oakland, California. Her first book of poems, *In Search of Landscape,* was published in 2007 by Sixteen Rivers Press.

MARDI WOOD, a potter in Bolinas, spends time in Italy drawing the native Maremma cattle. Scientists have found that these animals carry the original DNA of the ancient aurochs.

Connections

WRITING ORGANIZATIONS/EDUCATION

Marin Poetry Center
www.marinpoetrycenter.org

Mesa Refuge Writers Retreat
www.mesarefuge.org

River of Words
www.riverofwords.org

Tomales Bay Library Association
www.tomalesbaylibraryassociation.org

NEWS + INFORMATION

KWMR Community Radio
www.kwmr.org

Point Reyes Light
www.ptreyeslight.com

West Marin Citizen
www.westmarincitizen.com

ENVIRONMENT + WILDERNESS

Audubon Canyon Ranch
www.egret.org

Environmental Action Committee
of West Marin
www.eacmarin.org

Golden Gate National Recreation Area
www.nps.gov/goga

The New School at Commonweal
http://commonweal.org/new-school

Occidental Arts and Ecology Center
www.oaec.org

Point Reyes National Seashore
www.nps.gov/pore

Point Reyes National
Seashore Association
www.ptreyes.org

Regenerative Design Institute
www.regenerativedesign.org

Tomales Bay Watershed Council
www.tomalesbaywatershed.org

AGRICULTURE + LAND STEWARDSHIP

Agriculture and Natural Resources,
University of California
www.growninmarin.org

Environmental Forum of Marin
www.marinefm.org

Marin Agricultural Land Trust
www.malt.org

Marin County Cooperative Extension,
University of California Agriculture and
Natural Resources
http://cemarin.ucdavis.edu

Marin Organic
www.marinorganic.org

Marin Resource Conservation District
www.marinrcd.org

VISUAL ARTS

Art at the Cheese Factory
www.artatthecheesefactory.blogspot.com/

Bolinas Museum
www.bolinasmuseum.org

Claudia Chapline Contemporary Art
www.cchapline.com

Gallery Route One
www.galleryrouteone.org

Falkirk Cultural Center
www.falkirkculturalcenter.org

Marin Arts Council
www.marinarts.org

EVENTS

Dance Palace Community Center
www.dancepalace.org

Point Reyes Books
www.ptreyesbooks.com

San Geronimo Valley Community Center
www.sgvcc.org

Toby's Feed Barn and Gallery
www.tobysfeedbarn.com

West Marin Commons
www.westmarincommons.org

Tomales High School students (with instructor Rachel Somerville), *West Marin Review* Posters, 2010.

––––––

We remember with appreciation author and editor Blair Fuller (1927–2011), who helped promote Volume 1 of the West Marin Review *through Tomales Town Hall readings and who founded a local writing group. Blair provided a memoir for Volume 2 and served as a prose reviewer for Volume 3.*

West Marin **Citizen**

Speaking the language of West Marin

HOME DELIVERY!
Community Newspaper
Published Every Thursday

CATCH THE WEEKLY NEWS. Call 415.723.6948 or 415.663.8232
Online at www.westmarincitizen.com

GEOGRAPHY OF
PRACTICING THE WILD
2012–2013 POINT REYES, CALIFORNIA

GEOGRAPHY OF HOPE 2012–2013

Geography of Hope centers around the theme of the wild—
not only in respect to the natural world, but also as an inextricable
part of human character and culture.

Formerly a weekend-long annual event, this next GOH installment
will take place throughout the seasons of 2012–2013 with a
medley of presentations, workshops, outdoor excursions,
conversations, films, and art events. Writers, naturalists, storytellers,
artists, and educators will be our guides in this ongoing exploration
of re-awakening and incorporating the wild into our
contemporary lives and times.

*To know the spirit of a place is to realize that you are a part of
a part and that the whole is made of parts, each of which is whole.
You start with the part you are whole in.*

GARY SNYDER, *The Practice of the Wild*

POINT REYES BOOKS IS A PROUD PUBLISHER OF THE *WEST MARIN REVIEW*
WWW.PTREYESBOOKS.COM • 415.663.1542
STEVE COSTA AND KATE LEVINSON, PROPRIETORS

west marin review

Volume 4
DONORS

Nancy Bertelsen
George Clyde
Rebecca Foust
Michael and Connie Mery
Tin Barn Vineyard

Thank you!!

About the *West Marin Review*

West Marin Review
Volume IV, 2012

ISBN 978-1-937359-33-1
Copyright ©2012 *West Marin Review*
All works copyright by and courtesy of the
artists and authors, unless otherwise noted.

The *West Marin Review* is a publishing
collaboration among Point Reyes Books and
Steering Committee Members Nancy Adess,
Madeleine Corson, Steve Costa, Doris Ober,
and Ellen Serber.

Prose Reviewers

Nancy Adess	Doris Ober
Jim Kravets	Rick Ryan
Samantha Fernandes	Ellen Serber
Intern, Tomales High School	

Art Reviewers

Madeleine Corson	Thomas Heinser
Sara Duskin	Lila Purinton
Bree Terrell	Rachel Somerville
Intern, Tomales High School	

Poetry Reviewers

Julia Bartlett	Randall Potts
Nancy Bertelsen	David Swain
Madeleine Corson	

Volunteers

Calvin Algren	Don Lloyd
Mark Caballero	Kate Milliken
Martha Danly	Bernie Schimbke
Carola DeRooy	Pam Taylor

FRONT COVER Marnie Spencer, *Gullible's Travels*
(detail), 2008, acrylic, ink, and pencil on canvas,
15 × 12 inches

BACK COVER Susan Preston, *Lou's and
Francesca's First Hive*, 2007, photograph

Jane Hirshfield's poem, "Many-Roofed Building
in Moonlight," first appeared on the Academy
of American Poets website in 2012 to mark her
election to Chancellor of the Academy.

Managing Editor: Doris Ober
Associate Editor: Nancy Adess
General Manager: Ellen Serber
Designer: Madeleine Corson Design:
 Madeleine Corson, Willow Banks,
 and Lucy Kirchner
Advertising Manager: Linda Petersen
Prepress Consultation: Jeff Raby
Public Relations: Lila Purinton
Bookkeeping: Dianne Fradkin, Meg Linden
Proofreading: Mark Caballero, Arline Mathieu,
Claire Peaslee, Elisabeth Ptak
Distributor: Publishers Group West

SUBMISSIONS FOR VOLUME V
Submission guidelines:
http://westmarinreview.org or
info@westmarinreview.org.
Submissions accepted only by mail.
Mail submissions to:
West Marin Review
c/o Tomales Bay Library Association
Post Office Box 984
Point Reyes Station, California 94956

SUPPORT THE *WEST MARIN REVIEW*!
The *West Marin Review* is created through the
volunteer efforts of friends, neighbors, artists,
and writers. Donations are appreciated (and
tax-deductible). Please make checks payable to
the Tomales Bay Library Association and note
West Marin Review on the memo line. You are
also invited to volunteer. To learn how you
can help, write to info@westmarinreview.org.

Printed in China